Olympian

Gods

From the Dresden Sculpture Collection

Exhibition and Catalog
Kordelia Knoll and Saskia Wetzig
with Michael Philipp

With contributions by
Björn Christian Ewald
Kordelia Knoll
Saskia Wetzig

Barberini Studies
Edited by
Stephan Koja, Michael Philipp
and Ortrud Westheider

PRESTEL Munich · London · New York

Contents

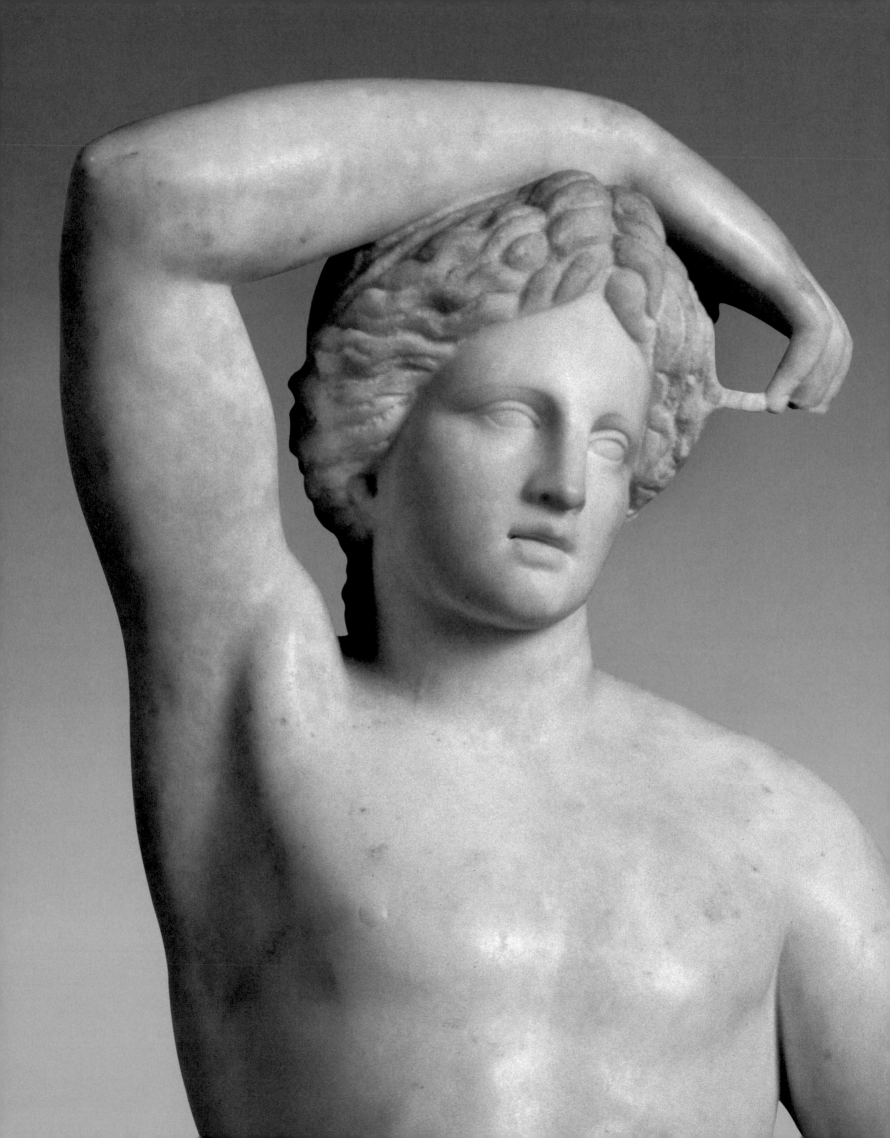

Foreword

Ortrud Westheider, Director of the Museum Barberini, Potsdam
Stephan Koja, Director of the Gemäldegalerie Alte Meister and the Skulpturensammlung (until 1800)
of the Staatliche Kunstsammlungen Dresden

The finely wrought statues of ancient Greece were a reminder of the presence of the gods. They symbolized power and an idealized beauty. When sculptors copied Greek models in the Roman imperial period, their sculptures exuded an aura of learnedness and erudition. The grace and dignity of these works may still be felt today. The Staatliche Kunstsammlungen Dresden hold one of the most important collections of ancient sculptures in Germany.

From this extensive collection, the Museum Barberini has selected sculptures that represent the most important Greek gods of the Mount Olympus, including statues so well known that—like the Dresden Zeus—they are known by their current location. These outstanding works show how Greek statuary developed over the centuries, depict tales from ancient mythology, and demonstrate the ways in which the gods were represented. The exhibition *Olympian Gods: From the Dresden Sculpture Collection* showcases these statues and explores the myths that surround them, with the aim of bringing their stories alive for visitors today.

Augustus II the Strong—elector of Saxony, king of Poland and grand duke of Lithuania—founded the Dresden Skulpturensammlung (sculpture collection), which assembled gods, heroes, and paragons of virtue at his court. He received the bust of Ares (cat. 12) and the herm of Hermes (cat. 45) as gifts from the king of Prussia, Frederick William I. After nearly 300 years these works have now found their way back to Potsdam. On their return to Dresden, they will be placed in their permanent home in the refurbished Semperbau.

Conceived in partnership with the Staatliche Kunstsammlungen Dresden, the exhibition continues a collaboration which began with generous loans for the exhibition *Behind the Mask: Artists in the GDR* and continued with *Gerhard Richter: Abstraction*, a show cocurated by the Gerhard Richter Archive and the Museum Barberini.

Together with Marion Ackermann, director of the Staatliche Kunstsammlungen Dresden, we would like to thank Kordelia Knoll and Saskia Wetzig for conceiving this project. Michael Philipp, the coeditor of this catalog, has developed the exhibition for the Museum Barberini. We extend our thanks to Kordelia Knoll, who has been head of antiquities at the sculpture collection for many years, and to her colleague Saskia Wetzig for their catalog contributions, as well as to Björn Christian Ewald for his introductory essay in the catalog, which is the second volume in our *Barberini Studies* series.

Embodying the Divine:
Images of the Gods in Classical Greece

Björn Christian Ewald

Now, as in ancient times, the peaks of the Olympus Range—some of which tower over 2,900 meters high—are often snow-capped and shrouded in cloud, while forests swathe their base. They were believed to be the home of the Olympian gods, who dwelt there in palaces built by the smith-god Hephaestus.[1] The gatekeepers of Olympus were the seasons (*horae*), who alternately opened and closed the blanket of clouds as the year turned.[2] The twelve Olympian gods were all siblings or children of Zeus, father of the gods. Zeus was the god of weather and the sky, the bringer of lightning and thunder, and thus was frequently worshipped in mountain sanctuaries and on the tops of the high peaks.

Power and Immortality:
The Society of the Olympians

The elder generation of Olympians was made up of Zeus, his sisters Hera and Demeter, and his brother, the sea god Poseidon. The gods of the younger generation included Athena, born from Zeus's head; the twins Artemis and Apollo; Hermes, the messenger of the gods; Ares, the god of war; and the clumsy but likeable god of craftsmen, Hephaestus. According to some accounts, Aphrodite, the goddess of love, was also Zeus's daughter with the oceanid Dione; others say that she was born from the foam around the genitals of Uranus, which fell into the sea after he was castrated by his son Kronos.

The twelfth Olympian god was either Hestia, Zeus's sister and goddess of the hearth, or Dionysus. Dionysus was the powerful god of wine and the theater, the offspring of Zeus's union with the mortal princess Semele, and was said to be particularly close to humans by virtue of this dual heritage. In the visual arts, Dionysus was far more popular than Hestia, and he is also shown among the assembled Olympian gods on the eastern frieze of the Parthenon.
The two generations of gods were depicted very differently. Zeus, Poseidon, and their brother Hades, the god of the underworld, were bearded father gods. The younger gods, especially Apollo, were usually youthful and beardless, although some depictions of Dionysus and Hermes deviated from this. Hera and Demeter, the first generation of Olympian goddesses, appear matronly, while Apollo's twin sister Artemis is maidenly.
According to Hesiod's *Theogony*, only three generations lay between Zeus's reign and the world's emergence from chaos. Out of this dark, bottomless, and formless "void"[3] rose Earth (Gaia), who gave birth to the Sky (Uranus). Uranus impregnated Gaia, but mistreated her and his children until he was over-thrown by his son, the Titan Kronos. The latter became an even more abusive father, but the establishment of the reign of the Olympian gods (the first generation of Olympians were children of Kronos and his wife and sister Rhea) under Zeus put an end to this brutal generational conflict, and a stable world order ensued. We can imagine Olympus as a divine, exurban counterpart to the fortified acropolises of the Greek cities. As the seats of Bronze Age rulers and mythic kings, the acropolises were ancient centers of power and religion, towering above the cities they ruled.

This distinction between above and below (which is also found in ancient political theory) is an important one: While democracy reigned close to the ground, authoritarian or oligarchic systems prevailed at greater heights.[4] Indeed, Olympian society was anything but democratic, even though the Olympian gods were of course also worshipped in democratic Athens. Zeus, the father of the gods, was more power-ful than all the other Olympians and ruled supreme. His tone was sometimes less than courteous. In a famous passage in the *Iliad*, he challenges his fellow gods to a kind of divine tug-of-war, claiming that even if all of them pulled on a golden chain he had fastened to the heavens, he would still be strong enough to lift them along with the earth and the ocean.[5] But although his powers were unequaled by the other gods, he was not omnipotent, and nor did he completely control them. Hera some-times managed to outwit him, and even in Homer's *Iliad* events sometimes slip out of his control, forcing him to adopt the more distanced stance of a mere observer.[6]
Greek mythology is characterized by the coexistence of many different and seemingly contradictory versions of myths. The aforementioned tales of Aphrodite's birth are just one example of so-called multiple truths existing in parallel.[7] Generally, the world of the Greek gods cannot be grasped logically. The gods were deathless and ageless, but had once been children and

belonged to different generations. They were supposedly happy and carefree, but this did not imply that they were always in a good mood, and they experienced anger, vexation, and fear as well as love, desire, and jealousy. Homer's gods sometimes even wept and wanted to be comforted. The ancient philosophers, for whom self-sufficiency was an essential attribute of the divine, already felt this to be problematic. The gods differed from humans by virtue of their immortality and their much greater power and vitality. This allowed them to traverse vast distances in the blink of an eye. Nevertheless, they could be wounded by mortal heroes and experience pain, like Ares and Aphrodite in the *Iliad*. In the myths, the gods shared a table with humans and received offerings from them, but they dined on nectar and ambrosia, not human food. Their bodies contained a balance of humors, just as human bodies were believed to do—however, not blood, but a fluid known as *ichor* flowed in their veins. The gods' social practices likewise only partly corresponded to the norms of antiquity. For one, they had incestuous relationships: Zeus's wife Hera was also his sister; he fathered a daughter, Persephone, with his other sister, Demeter, and gave Persephone to his brother Hades as his bride.

Last but not least, the gods were often capricious. If humans brought them offerings they were pleased, and they could be benevolent and helpful. However, mercy was not one of their fundamental traits, and the theological

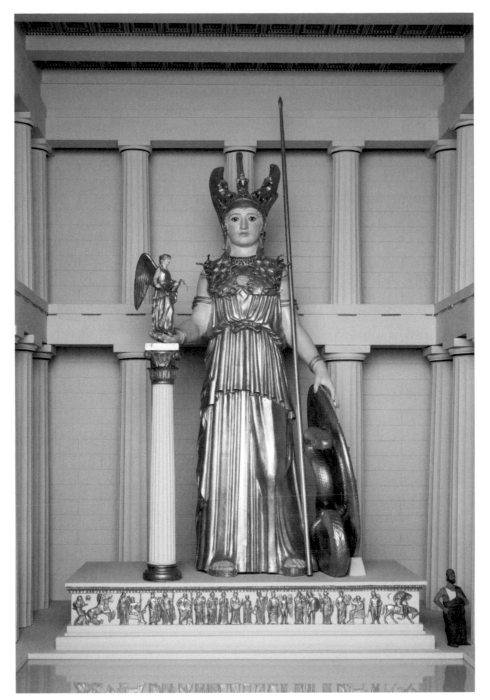

1 Reconstruction of the Athena Parthenos statue from 438 BCE made in 1970, Royal Ontario Museum, Toronto

problem of evil in the world was not a primary concern of Greek mythology. With the exception of a few, such as Dionysus, Demeter, and Aphrodite, the gods' existence did little to ameliorate the Greeks' pessimistic worldview. Far from it: The gods could also bring suffering, sickness, and death. They could cruelly deceive and manipulate humans, fool them through hallucinations, and appear to them in the form of other human beings, animals, or objects. Hera, Zeus's jealous spouse, brought about Semele's horrible demise in this way, and the promiscuous Zeus unscrupulously adopted a number of guises to achieve his ends.

Despite the intellectual criticism already levelled at the gods in ancient times, the deities were nevertheless present in human beings' everyday lives—and to an extent that would be difficult to imagine today. Children were told the tales of the gods by their nurses; adults invoked the gods in prayers, hymns, and dances;

and their stories were recited by rhapsodes and performed at religious festivals. Altars, sacred precincts, and temples were built in honor of the gods. And from the late geometric and archaic period onwards, they were also increasingly depicted visually, from aniconic stone monuments to elaborate works of art in all formats and materials imaginable. From clothing and textiles to the furnishings of public buildings, images evoking the gods appeared everywhere.

Presence and Agency of Divine Statues

2 *Saturn With Shackled Feet, Short Side of an Endymion Sarcophagus*, second century CE, National Archaeological Museum of Naples, Palestrina

Above all, it was statues that made the gods seem omnipresent in ancient times. The manner in which they are presented in museums today, inviting viewers to indulge in silent, aesthetic contemplation from afar and precluding any touching

of the statues as a matter of course, fails to convey how rooted in life they were in antiquity. In ancient Greece and Rome, people's relationships to statues were varied, ranging from a belief in their magical properties to the more distanced approach of the connoisseur and collector.[8] There was no unified, systematic concept of a statue's nature. In the simplest cases, statues represented deities and summoned their presence: Those making offerings before a goddess's cult statue (her *agalma*) were thus honoring the goddess herself. The statue made it possible to enter into an exchange with the deity—an exchange that was hoped to be binding on both sides. It was believed that the deity was somehow present in her image, or present at the sacrifice in some other way—usually one did not enquire exactly how, as this was of no importance to the ritual practice.[9] In the archaic period, however, deities could certainly be equated with their images.[10] But even then it was considered possible for the gods to leave their statuary bodies. This implies at least the possibility of the conceptual distinction common in the classical period.[11]

Besides serving as cult images, statues of gods were also erected in sanctuaries as votive offerings. These two categories differ with regard to their function and the aim pursued by their donors. Cult statues, which were usually (though not necessarily) placed in the interior of a temple, formed the point of reference for sacrifices and ritual acts, while votive offerings did not. However, no distinction can be drawn between them in iconographic terms.[12] Because of this, it is often impossible to determine the original function of the many types of statues that survive in copies and out of context. Only by knowing the context was it possible to define the Athena Lemnia as a votive offering and the

Knidian Aphrodite as a cult statue. Likewise, the different categories are not clearly distinguished from one another terminologically: The Greek word *agalma* can refer both to a dedicated statue and a cult image.

Besides statues of gods and heroes, there were also honorary and tomb statues of mortals. Statues of this kind functioned as monuments that perpetuated the depicted individual's social person in an idealized form, guaranteeing that he or she would live on. This was of crucial importance in a culture that knew no afterlife or rebirth in the Christian sense and that frequently sought to counter the transience of the human body with the permanence of marble and bronze. The statues' hoped-for durability, however, was often an illusion; in reality, they formed part of a collective memory that was constantly changing. In times of hardship, cities would often melt down some of their bronze honorary statues due to their material value[13]—a fate that befell most statues in late antiquity and the middle ages. Honorary statues whose recipients fell out of favor were melted down, and statues could also be stolen, sold, or rededicated by erasing their honorary inscriptions and replacing them with new ones.

While antique reliefs were painted and thus resembled paintings, the statues' three-dimensionality and physicality, as well as their polychromy, endowed the gods with a lifelike presence. They were treated like living bodies (*therapeuein*): Cult statues could be ritually washed, oiled, anointed, fed, and crowned with wreaths.[14] During the festivals of the gods, they were carried along in processions. They were able to move and even weep, bleed, and sweat.[15] In so doing, they could act as sensitive indicators of the political climate: During the period of the Roman Republic, temple images supposedly perspired intensely in situations of crisis.[16] Some statues, especially those of athletes, were purported to have the power to heal or bring good fortune. At times, this left its mark: The bronze statue of the battle-bruised boxer from the Quirinal Hill in Rome shows signs of wear, as it was already touched constantly in ancient times.[17] Statues could also function as talismans of their cities and grant refuge to those seeking shelter.[18] The creations of the mythical artist Daedalus are said to have been able to move, see, and speak:[19] The ideal of the imitation of nature, taken to its extreme, was defined as the highest form of artistry.

But cult statues could also turn their backs, close or avert their eyes, or even take flight if they wanted to express their displeasure, or if gross injustices took place in their presence. The most famous example is the statue of Athena which fled when Cassandra, who had sought shelter in her temple, was raped by Ajax.[20] Such tales of gods leaving or turning away seem to rationalize the fact that statues were unable to prevent wrongdoing despite the powers attributed to them—something the church fathers were quick to reproach them for. Statues could also be held down by chains to prevent them from running away so their powers could be kept in the community.[21] It was recently suggested that the model for the Ares Borghese (cat. 12) may have been chained up because the Roman copy in the Louvre has a ring around the right ankle.[22]

The statue of Saturn, the Roman god of agriculture, was bound by woollen bonds for most of the year in his temple in the Roman Forum (albeit for a different reason). These were only removed during the festival of Saturnalia in December. One of the short sides of a Roman Endymion sarcophagus shows the god in the bronze shackles (*compedes*) worn by slaves or prisoners (fig. 2).[23] Statues could also be whipped, toppled, shattered, and mutilated. In extreme cases, they could act as autonomous subjects. Thus some of them were said to have successfully resisted being stolen.[24] Other statues acted as the avengers of those they represented: A number of anecdotes recount how statues killed their tormentors by falling over on top of them. The best-known example is the athlete Theagenes's statue,[25] which had a very colorful history. Over the course of its existence, it was put on trial for murder and cast into the sea—only to be fished out again when the Oracle of Delphi, who had been consulted about a bad harvest, demanded it be rescued.[26] While rational criticism of this belief in miracles was already being voiced in ancient times, this condemnation never led to an abandoning of the gods or their veneration in the form of statues.

Simplicity and Severity:
Divine Bodies in the Classical Period

Around the mid-fifth century BCE, when the statue of Athena Lemnia was dedicated, the Athenians were "at the height of their political power."[27] Through a series of spectacular victories, the Persian threat had been averted. A peace treaty with oligarchic Sparta had given the Athenians a short respite in the long-smoldering conflict between the two cities, which was soon to erupt once more. The treasury of the Delian League—a defence alliance against the Persians led by Athens—had already been moved to Athens some years previously. Over the following decades, a portion of these tribute payments was used to finance extensive building work on the Acropolis. The visual programs of these richly decorated buildings speak of the Athenians' victoriousness and cultural superiority, of piety and ceremonial order within the city, and the averting of external threats. They also express the superiority of human emotional control and self-command to unbridled, animalistic energy and hubris. The important concept of autochthony—the idea that Attica's inhabitants had dwelt there since primeval times or had even risen from the region's soil—was closely interwoven with this.[28]

According to later sources, the artist Pheidias was the *spiritus rector* and source of ideas for the great works commissioned by Pericles. This is probably only a slight exaggeration, even though it underestimates the democratic decision-making process associated with such building projects during the period of the so-called radical democracy. Pheidias's images of gods reflect the Athenians' triumphal mindset at the height of their power more closely than those of any other artist. No one was able to convey better what we now call the "Olympian feeling"[29]: the impression that the gods are conscious of human beings' fates without being emotionally involved in those destinies. An aloof, august appearance was a key trait of Pheidias's cult images: They possessed both authority and weight (*megethos, megaloprepeia*; Lat. *maiestas, pondus*). Their mythological ornamentation, such as the depiction of the slaughter of the Niobids on the throne of the statue of Zeus at Olympia, illustrated the gods' punitive power. Pheidias's most famous statues owed their majestic appearance not least to their sheer size: The Athena Parthenos (fig. 1) and the Zeus at Olympia were each around twelve meters high and must have been overwhelming presences in the temples' interiors, which would have seemed undersized in comparison. The famous bronze statue of Athena by Pheidias on the Acropolis (Athena Promachos) was equally colossal; it formed part of the city's "skyline,"[30] and the tip of its spear and crest of its helmet were visible

from the sea. The exquisite materials used in Pheidias's temple images—glass and gemstones as well as gold and ivory—contributed to the astonishment and admiration (*thauma*) evoked in those who beheld them.[31]

A slightly earlier Athena by Pheidias, which visitors to the Acropolis would have encountered as soon as they entered the sanctuary, was the bronze statue that Attic colonists (*cleruchs*) on the island of Lemnos had dedicated to their patron goddess, the so-called Athena Lemnia (cat. 4).[32] Pericles may have had a hand in the dedication of the statue, which was directly linked to the politics of the Delian league; in any case, his own statue was later erected very close to it. The Athena Lemnia differs from Pheidias's monumental statues not only in her size, but in her civilian dress (she is not wearing her helmet). Assuming that the original bronze statue has been identified and reconstructed correctly, Pheidias created a friendlier image of Athena for the Attic *cleruchs*, a goddess disposed kindly towards the settlers: she seems "exalted yet approachable."[33] She appears similarly peaceable and helpful when assisting Heracles on the metopes of the temple of Zeus at Olympia. However, typically for the fifth century BCE, the Athena Lemnia is associated with present concerns rather than the heroic pursuits of earlier times. The discovery of the present, and of contemporaneity, was an achievement of the late sixth and early fifth centuries BCE, when artists began to break through the mythical temporal horizon.[34]

Votive offerings such as the Athena Lemnia not only honored the deity, but also served the self-representation of their contemporary donors in one of Greece's most central places of communication. Yet in the case of the Lemnian Athena, the political message

seems to have been gradually overshadowed by the statue's artistic value. It became famous for its stern beauty: Pausanias referred to it as "the best worth seeing of the works of Pheidias".[35]

Athena's appearance is characterized by an austere, almost severe elegance. The blocklike form of the statue offers distinct, independent angles of viewing. Unlike the female figures of the later fifth century BCE, whose curves are eroticized by elaborate drapings and translucent garments, here the body is still completely subordinate to the clothing that covers it. The contours of the free leg, slightly bent in "Polykleitan" contrapposto, are only just visible under the rigid drapery of the peplos. The impression of solemn severity and loftiness is only partly mitigated by the inclination and turn of the head, and the gestures of the arms: Athena probably held a helmet in her right hand, and a lance positioned aslant in her left.

Athena's lofty severity formed part of a program, a cultural habitus that emerged from the abolition of tyranny and the Greeks' victories over the Persians. From the Greek perspective, the Persians lacked moderation above all else: Only a few decades previously, their king Xerxes had given the order for the Greeks' temples and the images of their gods to be plundered and burned. Daring to compete with the gods, Xerxes even had the Hellespont (Dardanelles)

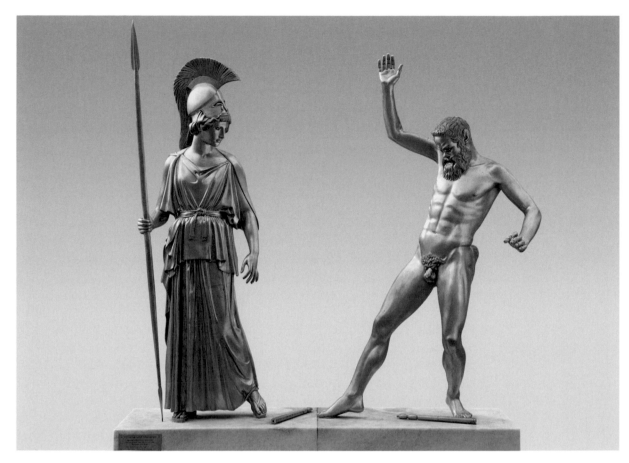

whipped and shackled for refusing to obey him, and thus became an archetype of (swiftly punished) hubris. In visual representations, the Persians are usually characterized by their highly ornamental clothing. However, richly decorated, colorful clothes are also found in female statues (*korai*) of the late archaic period, as the aristocratic society of the sixth century showcased its personal power and wealth through increased splendor. By contrast, after the abolition of the aristocracy, the Greeks embraced an ideology of moderation and self-control that sometimes quite ruthlessly placed the collective above the individual and even went so far as to banish influential citizens through the legal procedure of ostracism (*ostrakismos*). This self-restraint and emotional control are also reflected in statues' expressions. While late archaic *korai* still display a restrained smile as a sign of grace, or a sign of gratitude (*charis*) to the gods, the Lemnian Athena's impassive yet animated expression is typical for the age of Pericles. Her clothing retains some of the characteristics of the so-called severe style, which marks the transition from the luxurious female garments of the archaic period to a simple peplos. Splendor and sartorial luxury continued to exist, but only as part of the collective rituals in which the *polis* community honored their patron goddess: Every four years during the Panathenaic festival, Athena was gifted with a peplos woven by Athenian maidens and decorated with an image of the Gigantomachy.

Even though the Greek self-image of the early classical period was largely conceived as a contrast to the image of the Persians, it is important to recall that the Greek concept of the "oriental" changed considerably over the fifth century, gradually taking on more positive attributes—in parallel to a subtle change in the Greeks' attitude towards luxury and splendor.[36] The image of the Persians in Aeschylus's tragedy *The Persians*, first performed in 472 BCE, only eight years after the naval victory at Salamis, is already strikingly complex.

Gods and Humans in the Parthenonic Period: A Rapprochement

During the Parthenonic period, the third quarter of the fifth century BCE, the gods, who had long been portrayed in human form, became even more thoroughly humanized. It has often been suggested that if gods start resembling humans, this implies that humans move closer to the gods. At a time when the Athenians could hardly put a foot wrong, and almost anything seemed possible, humans were indeed seen as the measure of all things. On the eastern frieze of the Parthenon, the Panathenaic procession culminates in an assembly in which humans are mingling with

Olympian gods. This was an attempt to show the present political order as a natural state of affairs, thus imbuing it with authority.

The Dresden Zeus type (cat. 2), created around or shortly after 430 BCE, is a further example of this humanization—or rather, democratization—of the gods. The father of the gods poses with his left arm on his hip in the casual manner of an Athenian citizen going about his business in the agora or the popular assembly. Apparently the Athenians' pride and confidence were so great that even the authoritarian Zeus is shown as a democratic "everyman." The Dresden Zeus has been attributed to Pheidias or one of his pupils, and its type matches that of its likely model, the statue of Zeus Eleutherios that stood in front

3 Modern reconstruction by Peter C. Bol and Silvano Bertolin of the Athena-Marsyas group by Myron dating from circa 450 BCE, Liebieghaus Skulpturensammlung, Frankfurt

of the stoa of the same name in the Athenian agora.[37] The cult of Zeus Eleutherios revered the father of the gods as a liberator who protected his followers against foreign rule and tyranny from within.[38] Literary sources often equate it with the cult of Zeus the Savior (Zeus Soter), from which it probably developed during the Persian Wars.[39] As a Panhellenic cult, it was found not only in Athens but in numerous other Greek cities. However, the depiction of Zeus Eleutherios as an Athenian citizen attending to political affairs clearly demonstrates how much Athens's political practice owed to the freedom fought for in the Persian Wars and safeguarded by Zeus.

The Ares Borghese type (cat. 12), probably created only a few years after the Dresden Zeus, represents a similarly peaceable and seemingly reformed god.[40]

4 *Statue of Zeus,* from the sea at Cape Artemision, circa 460 BCE, National Archaeological Museum of Athens

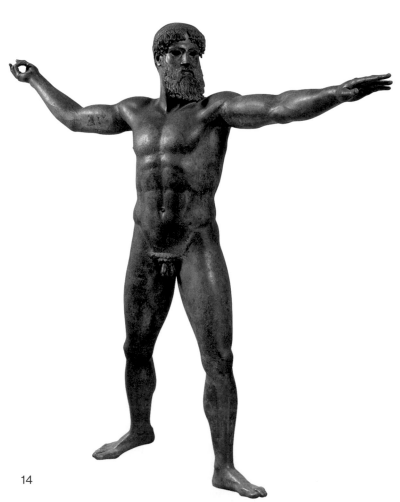

Ares is not portrayed as the wrathful warrior of epic poetry or the dynamic fighter of archaic vase paintings, but simply as a god standing calmly in his athletic nakedness. The gentle inclination of his youthful head makes him seem almost pensive; his helmet is decorated with reliefs of griffins and crowned with a sphinx. The weapons he originally held in his left hand, shield and lance, are mere attributes; the sword belt was probably not part of the original but instead was a Roman addition.

This type, which exists in several copies, can be traced back to a statue created around 430–420 BCE by Alcamenes for the temple of Ares in Athens. Shortly after the mid-second century CE, the writer Pausanias saw a statue of Ares by Alcamenes—one of Pheidias's master students—in Ares's sanctuary (*hieron*, so not indubitably within the temple) in the agora in Athens.[41] This recorded identification—which, like the date, has been contested—seems reasonably likely, since no other important classical images of Ares are attested to in literature and almost no other large-scale depictions of the god from this period have survived.

However, the temple of Ares had only been moved to the Athenian agora during the reign of Augustus as part of a remarkable "musealization." We neither know whether the same applies to the statue, nor whether this type originally formed part of a group of statues. In Roman times it was frequently used in group compositions, and the Dresden example also belonged to a "concordia" group showing Ares with his lover Aphrodite (fig. 13). Pausanias mentions two statues of Aphrodite (fig. 8) and one of Athena by the Parian sculptor Locrus, the torso of which may have been discovered. The most recent attempt at reconstruction (which has not been uncontroversial) combines all of

the statues mentioned by Pausanias to recreate the temple's Augustan cult group.[42]

The Emancipation of Experience: Towards the Late Classical Period

The beginning of the protracted Peloponnesian War (431–404 BCE), which was only briefly suspended by the Peace of Nicias of 421 BCE and the outbreak of a devastating plague in 430 BCE, marked decisive turning points. The Athenians' triumphal self-image and their trust in democratic institutions and their own, superior rationalism were severely shaken over the years that followed. Thucydides gives a vivid description of the almost-total collapse of civil order in Athens.[43]

Pericles, the ambitious leader of Attic democracy, was one of many victims of the epidemic. Athens was never to recover from these blows: The early fourth century BCE was marked by struggles over the hegemony of Greece between Sparta, Athens, and Thebes until the rise of Macedonia under Philip II and his son Alexander finally put an end to the independence of the Greek city-states. Yet the tumultuous events of this time did little to harm artistic productivity and inventiveness; the plague even brought about a renaissance

of an important class of archaeological monument, the Attic grave relief. Social attitudes and values changed considerably during this period. Unlike in previous decades, people did not see themselves exclusively or principally as part of a collective but as individuals whose personal feelings and experiences mattered and who longed to find expression. Fourth-century grave reliefs thus tended to focus on the domestic sphere (*oikos*) and the relationship between members of a household. One significant manifestation of this shift in attitudes was the growing appeal of cults which offered worshippers a closer emotional bond to the gods and promised a good life, pleasure, and well-being.[44] This explains the popularity of divinities like Dionysus, Aphrodite, and Asclepius, the god of medicine whose cult had been introduced in Athens in 420 BCE, some time after the plague. A mortal half-god, Asclepius was born twice (according to one version of the myth) like Dionysus, and his mortal mother was Koronis. He was thus closer to humans than his divine father Apollo, who was not just the god of healing but could also bring sudden death and was often unmoved by human suffering.[45]

The Greeks were certainly not abandoning the great gods of *polis* religion, like Athena and Zeus—even though some Sophists of the late fifth century espoused a veritable agnosticism. But the focus was shifting and new themes were being explored,[46] and these

changes would have a great impact on the development of art in the late classical and Hellenistic periods. The most daring inventions of the sculptors of the late classical period no longer address the collective concerns of the *polis* but show gods in private, even intimate moments that appear almost random and marginal from a mythological perspective. Unlike Pheidias's monumental statues, these sculptures do not aim to create a timelessly valid image of a divine being, but depict concrete, often genre-like or even everyday scenes. We see fewer gods appearing as inventors—like Athena in the Athena and Marsyas group by Myron (fig. 3)[47]— or supporting heroes or settlers like the Athena Lemnia, but instead are confronted with gods undressing to bathe (Aphrodite) or interacting with other, younger gods and personifications (figs. 5, 6).

During the fourth century many gods seem to be afflicted by a strange weariness: Olympians are no longer engaged in the kind of energetic activity we know from mythology (like the god from the sea, fig. 4); instead we frequently encounter them when they have just accomplished their deeds and are resting. While the contrapposto figures of the fifth century BCE, especially those by Polycleitus, stood solidly "by their own efforts,"[48] Praxiteles's statues lean casually against the props supporting them. The Apollo Lyceus, probably created by Praxiteles or his Athenian contemporary Euphranor, serves as a good example of this. Apollo's right arm is bent over the top of his head in a gesture of repose; his left hand holds his bow. The support, which in the Dresden copy takes the form of a tripod with a snake, suggests that the image may portray Apollo after he has slayed the Python (cat. 5).[49]

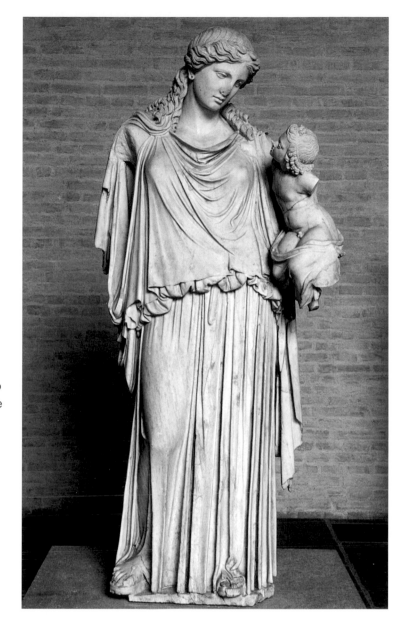

The original Apollo Lyceus stood in the gymnasion known as the Lyceum in Athens, where Lucian saw a statue of Apollo "resting after some great exertion"[50]; it had probably been created in the context of a reform of the Attic ephebeia in 336–35 BCE. Placed in one of the most important educational institutions in Athens, this god (who in the Dresden copy seems almost prepubescent) became a model for the boys

5 *Statue of Eirene and Plutus*, Roman copy after a Greek original, 370 BCE, Glyptothek, Munich

and ephebes engaged in their athletic exercises, demonstrating a physical habitus that was both casual and controlled. The sculpture's aesthetic was fitting for the homosocial environment of a public space where young men were subject to the scrutinizing and admiring gaze of older men. And there was another reason why artists in the fourth century often represented their figures in moments of repose: It was a way of making their inner lives visible. The cultural historian Jacob Burckhardt expressed this eloquently in his

comments on the art of the fourth century BCE: "This age was more subjective in spirit, and aimed for a deeper feeling and a livelier expression of mood; this was the time of the gods of enthusiasm, longing and melancholy, the time for dreaming, and for the most exquisite charm and moulding of form illuminated by wonderful qualities of intimacy."[51]

Sophists and Artists:
The Valorization of the Individual

This shift of focus from the collective to the individual is also reflected in the cultural movement known as Sophism, which flourished during the late fifth and the early fourth centuries BCE. Sophists valued subjective experiences, opinions, and judgments, which they thought had previously been neglected.[52] The intense culture of debate in the democratic city-states gave a clear advantage to the most accomplished orators, who knew how to get the audience on their side. This contributed to the rise of the Sophists, whose most famous exponents, such as Isocrates, Protagoras, and Gorgias, saw themselves not just as itinerant teachers of rhetoric, but as representatives of a kind of cultural avant-garde. Their

flamboyant appearance befitted this self-image.[53] Espousing a pragmatic, flexible form of intellectualism, which did not seek any immutable truth behind the world of appearances, the Sophists often let the weaker argument prevail. They were known for their public debates, in which they used an elaborate vocabulary, a great variety of rhetorical figures, and sparkling flourishes of logic. In a nutshell, they offered highbrow entertainment and were very popular among the young people of Athens. Many visual artists of this time seemed to emulate the Sophists. Sculptors created explosive optical effects with a new style of rendering drapery: Swirling, cascading folds, seemingly functionless and following no logic but their own, aimed to dazzle and beguile the viewer with the virtuoso display of their execution. The reliefs on the parapet of the temple of Athena Nike (around 425–420 BCE) and some Aphrodite statues in the so-called "rich" or "wet" style are excellent examples of this (fig. 8). In these sculptures, the drapery seems nervous, as if charged with some kind of inner, subconscious energy. This was more than a mere rhetorical device employed to capture viewers' attention: The tragedies of Euripides (ca. 480–406 BCE), written around the same time, are testimony to a huge interest in mental states and processes. The lofty, simple style of the mid-century, with its message of self-command and emotional control, had come to an end, at least for a while. Some fourth-century artists, however, continued to draw on styles of the fifth century, using them in parallel with the new styles. The Dresden Artemis's heavy, almost viscous-looking peplos is reminiscent of the peplophoroi of the

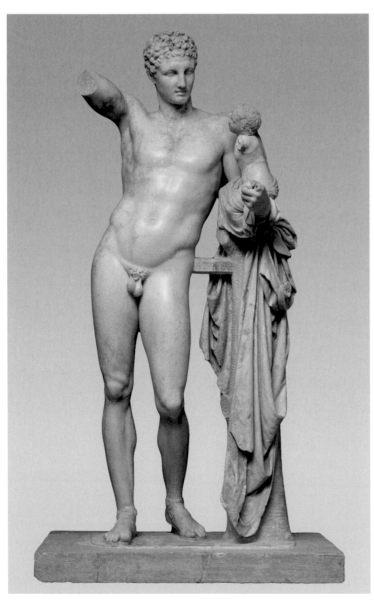

6 *Hermes of Olympia by Praxiteles*, possibly an original from circa 340 BCE, Archaeological Museum, Olympia

severe style. Like the cloak of the Lemnian Athena, it conceals the body thoroughly and is thus a fitting garment for the chaste virgin goddess of the hunt (cat. 6). Much the same can be said of Cephisodotus's statue of Eirene with the boy Plutus, which was created around or shortly after 370 BCE. One figure personifies peace, the other the childlike prosperity safeguarded by that harmony (fig. 5).

This valorization of the private and personal, of the good life and individual experience, which is reflected in the changing perception of the gods, must be considered in the context of more general changes in different spheres of life during the late fifth and fourth centuries BCE. In the fifth century, private, domestic luxury had been frowned upon: Early and high classical interiors of houses were only sparsely furnished. Sculptures and murals with mythological themes were mostly reserved for public spaces, sanctuaries and temples, agoras and porticos. Signs of private luxury start appearing in the late classic and early Hellenistic periods: The first figural mosaics in domestic contexts were found in houses of the fourth century BCE.[54] Ostentatious displays of wealth were still occasionally the subject of political discourse in the fourth century, as

demonstrated by the example of Demosthenes, who was criticized for indulging in excessively luxurious (even effeminate) clothes,[55] but attitudes towards private wealth and luxury were generally more relaxed than in the previous century.

Attic vase painting of the late fifth and fourth centuries BCE, also referred to as the Kerch style after an important archaeological site, was dominated by colorful, almost saccharine depictions of Aphrodisian or Dionysian themes evoking a carefree world full of love and feminine beauty. Some scholars have interpreted this development, which set in during the Peloponnesian War, as a form of escapism.[56] It can also be understood as the tentative semiotization of new fields of experience. Depictions of the gods in private or seemingly everyday situations brought them into the present and simultaneously ennobled viewers' own experiences: Themes such as undressing before bathing or resting after great exertion needed no mythological justification or knowledge in order to be understood. They made it possible for the gods to be experienced directly and intuitively. Yet at the same time these gods still appear strangely aloof: Acting within their own space, like the Aphrodite of Knidos, they seem to ignore us; or they appear dreamy, wrapped up in what they are doing, like Praxiteles's Hermes of Olympia (fig. 6) and the Farnese Hermes, who is depicted in a similar stance (cat. 14). They are certainly still powerful gods, who—to paraphrase a verse from Rilke's *Duino Elegies*—"serenely disdain to annihilate us."[57] And although it is often only alluded to in a very subtle and refined manner, the mythological context never vanishes completely.

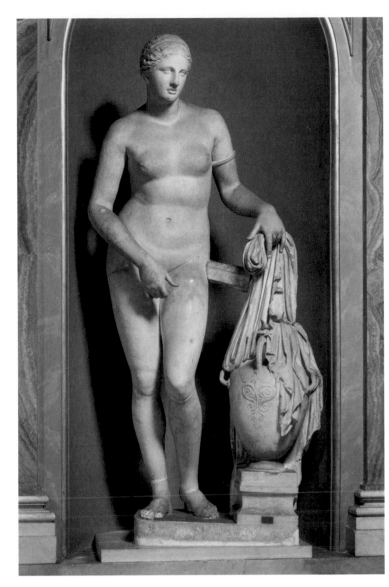

Aphrodite's Bath: Nudity in Greek Art

No other work exemplifies this better than Praxiteles's most famous statue, the Aphrodite of Knidos,[58] one of the most celebrated and most copied works of all antiquity. Probably very soon after its creation around 360 BCE, numerous copies and adaptations were produced, and although they vary in their contrapposto stance and position of the arms, the original always remained recognizable.[59] One such version is the Capitoline type,[60] which differs from Praxiteles's Knidia in its pronounced *pudica* gesture: While the Knidia picks up (or puts down) her cloak (fig. 7) with her left hand, the

7 Venus Colonna, Aphrodite of Knidos Type, Roman copy after an original by Praxiteles, circa 360–350 BCE, Vatican Museums, Rome

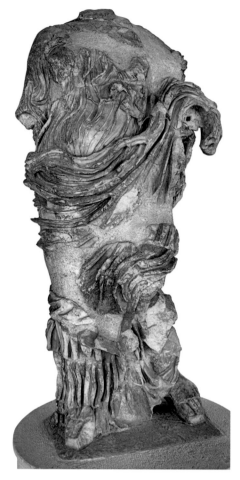

Capitoline Aphrodite uses both hands for concealment: The left is extended over her breasts, while the right shields her genitals. This modest gesture is often interpreted as the goddess's reaction to being surprised by an intruder, although not all scholars share this assumption. Ancient sources describe the creation of Praxiteles's statue,[61] and how its acquisition helped to turn the remote city of Knidos into a tourist attraction. The master had produced two sculptures of Aphrodite, which he put on sale simultaneously for the same price: one clothed, one naked. (Along with other anecdotes, this suggests that the wealthy artist maintained a proper artist's studio.) The conservative citizens of the island of Kos preferred the attired statue, while the Knidians opted for the unclothed version, which was said to have been modeled on Praxiteles's mistress, the courtesan Phryne.[62]

The Knidians' choice might have been influenced by a local cult tradition and its naked figurine representations of the Phoenician goddess of fertility Astarte, who was often equated with Aphrodite. Despite this, we should not underestimate the intensity of the shock caused by Praxiteles's Aphrodite. It was the first monumental statue representing a female Greek divinity completely naked, and this over life-size cult image must have caused a stir. In the late classical period, naked male athletes practicing or taking part in cultic processions and performances were a common sight, but women wore long garments and often had their heads veiled. Inadvertent voyeurs such as the mythical hero Actaeon were punished by death even if they had observed a naked goddess during her bath by pure chance; men were therefore not even allowed to take part in "some bathing rites of female divinities." [63]

In art, too, nakedness was above all reserved for the representation of men, no matter whether they were gods, heroes, or mortals. Male nakedness had many different meanings in Greek art.[64] The naked athlete represented the physical and mental ideals of Greek education (*paideia*) and was at the center of a strong homosocial visual culture which exalted the male body. Athletic nakedness was also a cultural marker which the Greeks used to set themselves apart from the barbarians (i.e. non-Greeks). When his soldiers were outnumbered by the Persians, the Spartan king and commander Agesilaus is said to have emboldened them by parading some naked Persian prisoners of war in front of them. Seeing these pallid, overweight, and untrained bodies, the soldiers concluded that the impending battle would be no more difficult than one against women.[65] That nakedness was seen as the norm for men

has been interpreted by some as the expression of a "reductionist" worldview which ascribed both "success" and "failure" to physical qualities.[66] Depictions of naked women on the other hand were rare, and only a few examples are known from archaic and early classical vase painting.[67] These women were *hetairai* and mythological figures of lower rank, such as the enchantress Circe; Cassandra, victim of a brutal rape by the younger Ajax, was also represented partially naked. It was not until the "rich style" of the fifth century BCE that artists began to aestheticize and eroticize female forms by enticingly draping diaphanous fabrics over women's bodies.

This was a challenge for an aesthetic which until then had been decisively homoerotic. One influence may have been the fashionable self-stylization of the Sophists, which had made men appear more feminine. Women now had to look even more female to restore the gender difference.[68] The eroticization of female bodies also corresponded to the growing importance attached to female beauty and attractiveness in marriage, which had moved far beyond an institution serving merely to produce new citizen soldiers for the city-state.[69] There is nothing to suggest, though, that the Knidia's complete nakedness was anything but an original invention of

Praxiteles. Nonetheless, even he had to make some concessions: While male figures, such as the Belvedere Apollo or Lysippus's Apoxyomenos proudly displayed their naked bodies with centrifugal movements extending into the space surrounding them, the Knidia seems to lean forward somewhat hesitantly, and the contours of the Capitoline Aphrodite's body are completely closed. These Aphrodites do not seem to be as comfortable in their naked skin as their male counterparts. The nakedness of the goddess of love stirred many different mythological associations in those who saw her. In many places, ritual baths played an important role in Aphrodite's cult.[70] The *loutrophoros*—a vase used to carry water for a bride's pre-nuptial ritual which often served as a support for marble copies of the Capitoline Aphrodite—suggests that the goddess might be preparing herself for her wedding with Hephaestus.[71] Viewers might also have thought of Aphrodite's birth from the foam which gathered around Uranus's castrated genitals after they had been thrown into the sea; the Ludovisi Throne, created one century earlier, shows Aphrodite rising from the sea in a wet gown (fig. 9). In Knidos, Praxiteles's cult image was venerated as Aphrodite Euploia, the goddess of safe seafaring—fittingly enough, since the city, at the tip of a peninsula, was best reached from the sea. The details of the statue's original setting are controversial; what we do know is that visitors could admire it from all sides and that the direct,

sensuous impact it had on its viewers was already legendary in antiquity. According to one famous anecdote, an admirer of the Knidian Aphrodite hid in the temple with her overnight; a stain or blemish on the marble was taken as testimony to this indecent encounter. Another statue by Praxiteles, the Eros of Parium, was said to have suffered a similar assault leading to staining.[72]

"What Makes a Man a Man?"
Images of Male Bodies in the Fourth Century

Praxiteles was not the only sculptor to explore the sensuous aspects—one might almost say the tactile presence—of male and female bodies. During the fourth century, the surface treatment of bodies became generally softer, although this varied according to the tastes of Roman copyists. In contrast to the clear segmentation of

muscles in fifth-century figures, especially Polykleitan ones, flesh surfaces were now modeled with soft, almost imperceptible transitions. This new sensuousness must have marked a shift in the way people felt about their own bodies. It can be interpreted as a sign of a new sensibility and a new perception of the body as a medium of experiencing the world. The male bodies of the fifth century BCE have often been likened to armor, and it is indeed true that the tight-fitting muscle cuirasses which have long lost their original color can scarcely be distinguished from the bodies beneath them.[73] The bodies of fourth-century statues, especially those by Praxiteles, are very different. A feature that contributes to the sensuousness of these fourth-century statues is the way the hip is projected above the weight-bearing leg. The motif of the swaying hip first appeared in female figures of the high classical period,

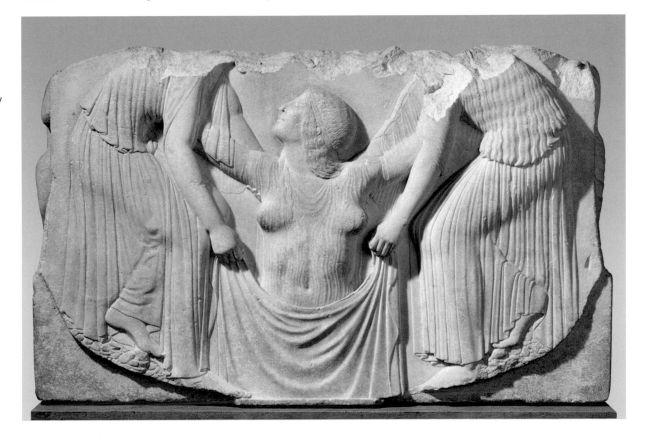

9 *So-Called Ludovisi Throne, Aphrodite Rising From the Sea*, circa 460 BCE, National Museum, Rome

such as Alcamenes's Aphrodite in the Gardens, mentioned by Pausanias,[74] and was later adopted for male sculptures, for example the Apollo Lyceus (cat. 5) and the Farnese Hermes (cat. 14). Standing calmly or casually leaning on a support, these figures seem to be traversed by a sinuous S-curve. Their elongated and slender proportions, which are mirrored in the architecture of the same period,[75] emphasize their gracious and elegant, sometimes almost voluptuous appearance. To understand this new body language, and indeed the new taste for slender proportions and elegance, we must return to the Sophist movement in Athens of the later fifth century BCE. The physical mannerisms of this cultural avant-garde seem to have started a stylistic trend. They were seen as refined, urbane, and cultured, though the style's detractors vilified them as effeminate and silly. In a key moment of Aristophanes's comedy *The Clouds* from 423 BCE, a biting satire on the sophistic culture of the time, a proponent of the "stronger argument" contrasts the athletic physique of the heroic victors of Marathon with the pretentious, effeminate manner of the Sophists.[76] The athletic ideal of the good old days had radiant skin, a strong chest, broad shoulders and buttocks, and small genitals. The Sophist physical type, on

the other hand, had narrow shoulders, a puny chest, a pallid face, small buttocks, and large genitals. What Aristophanes (446–386 BCE) offers in this passage is an incisive comparison between male statues from around the time of his birth (for example the athletic figures of Polykleitos) and, to judge from vase painting, a rapidly changing concept of masculinity. Pictorial evidence shows that the habitus he derided gained widespread acceptance during the course of the fourth century—with the exception of genital size, where the respectable small-is-beautiful aesthetic prevailed. With the adoption of "female" traits, concepts of masculinity were starting to become blurred,[77] a bold transgression which would continue with slight variations until Roman times.

Showing their Colors:
The Polychromy of Antique Statues

Most statues created in the ancient world were painted in bright colors. We know this from traces of paint preserved on many of the works and from a number of written sources which suggest that the painting of sculpture was a common practice in antiquity.[78] Famous sculptors collaborated with painters hardly less famous: It was said of Praxiteles that his favorite marble sculptures were the ones that were painted by Nicias.[79] Even the great sculptor had to concede that only a first-rate painter was able to bring stone to life.
And although most painters could not hope to emulate Nicias, and the quality of their work did not always match that of the sculptors,[80] the appearance of a statue was determined to a large extent by the way it had been painted. Skin was often depicted in a light-brown

hue, sometimes veering more towards pink, sometimes towards red, or the corresponding areas were left bare. Women were painted with lighter or even pure white flesh tones. This reflected domestic ideals and virtues and also corresponded to medical conceptions of the female body. Clothes were rendered in a range of colors from a light ocher to red, green, blue, or pink. Eyes owed their expressiveness not just to paint but also to inlays of various materials (fig. 10). The background color for reliefs in the classical period was usually a bright blue. Although it seems that there was no color symbolism comparable to that in medieval art in Greek antiquity,[81] royal purple was used in polychromatic sculpture to mark the rank of certain figures.
Paints were made from natural pigments which were dispersed in binding media such as egg, casein, or wax.[82] These included vermilion, a variety of natural iron oxides, minerals such as azurite and malachite, but also plant-based dyes such as madder (*rubia tinctorum*). It is not always clear how opaque these paints were and how much of the gleaming surface structure of the Greek marble remained visible.[83] Some of the extant traces suggest that relatively pastose, opaque layers were applied whose thickness depended on the size of the color crystals. Bronze statues, too, often had colored parts, in the form of artificial patination and inlays of copper, gold, or silver.[84] Producing these polychrome elements required enormous skill and knowledge,[85] and the Athenians

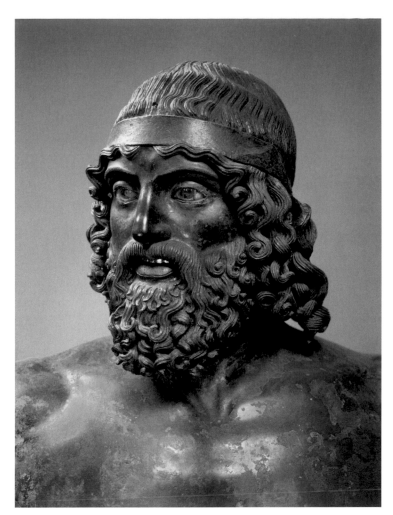

were justifiably proud of their ingenuity and technical know-how. There were also composite figures, which combined different materials such as marble, bronze, wood, and ivory to create striking contrasts of textures and colors. If painted sculptures were placed in the open, such as on the Acropolis or the agora, the delicate organic pigments probably had to be refreshed from time to time, and it is likely that on such occasions the painting was adjusted to changing tastes. The Dresden Asclepius statuette is a good example (fig. 11).[86] Its robe was initially painted red but a white ground overpainted with a vivid pink was added later, which is still clearly visible today. The contrast between the robe and the polished marble of Asclepius's naked upper body—which had been left unpainted—would have appeared even greater than it is today. Much the same can be said of the Dionysus with Nebris (cat. 13).[87] The thin animal skin which is tightly wrapped around the body must have contrasted strongly with the lighter flesh tone. The wine god's sparse clothing thus enhanced the erotic effect of his androgynous body.

It has been known since the nineteenth century that ancient sculptures were painted in color, and this knowledge has challenged the classicist idea that antiquity always means white marble. Over the last few decades, the polychromy of sculptures has become a field of archaeological research which has involved in-depth technical analysis. Yet despite continuing investigations, many questions remain unanswered. It is not clear, for example, to what extent the flesh tones of late archaic or classical marble statues were painted.[88] Nor can it be said with certainty how certain formal developments were accompanied, enhanced, or perhaps toned down by painting. Did the adoption of "female" elements in the iconography of male sculptures in the fourth century—the projecting hip and soft modeling of flesh surfaces—go hand in hand with lighter flesh tones?[89] What we do know is that the austere aesthetic of the age of Pericles, which challenged the luxury and splendor of the late archaic period, was mirrored in the painting of statuary: As far as we can still judge this today, the Parthenon sculptures eschewed the rich ornamental decorations and borders that had been typical of archaic garments, and the tonal values of their colors were probably "muted by the addition of white."[90]

Old Wine in New Bottles: Roman Copies of Greek Sculptures

The ancient sculptures which we see today are not classical Greek originals but Roman marble copies and adaptations that were mass-produced in the first two centuries CE. The Dresden collection alone possesses several versions of the same Greek original—for example, the Athena Lemnia or the Capitoline Aphrodite. We thus look at Greek classical sculpture through the lens of Roman copyists—with the exception of the very few original works that have been preserved through lucky circumstance. What led to this Roman mass production of copies?[91] The historical background to this phenomenon is well-known. Following the Roman expansion in the late third and early second centuries BCE, large quantities of artworks came to Rome as war booty from the Greek cities of southern Italy and Sicily and from Greece itself.[92] The plundered treasures were presented to the amazed Romans in spectacular victory processions known as "triumphs" before being exhibited in temples or porticoes built by the victorious generals; some pieces ended up in private collections or occasionally in public sanctuaries. The quantity of artworks brought to Rome was enormous: The triumph of M. Fulvius

10 *Riace Warrior A,* mid-fifth century BCE, Museo Nazionale della Magna Grecia, Reggio di Calabria

Nobilior in 187 BCE contained more than 500 bronze and marble statues, and the triumph of Aemilius Paullus nineteen years later paraded no fewer than 250 wagonloads of looted art. Soon many Romans began to appreciate the plundered works not just for their material value or as war trophies but also as artworks which they could collect or sell. Their precious materials and artistic refinement were often seen as superior to the colorful Roman terracotta sculptures, which seemed old-fashioned, simple, and rather crude in comparison. This caused concern among conservative hardliners in Rome who claimed that the imported Greek artworks had an effeminizing, or even subversive, effect, and that they undermined traditional Roman values.[93] The accusation was probably aimed more at the behavior of self-proclaimed connoisseurs and art collectors—their idle debates and feigned expertise—than at the artworks themselves. But the occasional anxiety about Greek art becomes less surprising if we take into account that, according to written sources, the sensuous sculptures of Praxiteles and other late classical artists were overrepresented among the looted artworks.[94] Depicting naked male and female bodies as a matter of course, these sculptures appealed to the carefully suppressed fantasies, desires, and emotions of their viewers and challenged the self-image of male aristocrats, which was based on martial virtues and loyalty to the state. It was no coincidence that artworks were also regarded as alluring pleasures, *voluptates* and *deliciae*. Moreover, the enthusiasm for Greek art was only one aspect of a broader process of acculturation born out of the encounter with Greek high culture in the East.[95] Together with the spoils of war, Greek architects and their materials came to Rome, soon followed by teachers, philosophers, and educators, as well as actors and artists. This created a cultural superstructure in which the assimilated Greek elements gradually merged with traditional Roman culture.

Increased demand for Greek art soon led to the mass production of copies. Molds were taken from the original statues in Athens and elsewhere to make plaster casts,[96] which were then used as models for marble copies and versions produced in Italian workshops. The choice of originals was determined above all by the tastes and needs of the Roman clientele; their opinion counted for more than the artistic status of an original work or the reputation of its creator. The most popular statues were often those that stood in an easily accessible place, such as the Athenian agora or the Acropolis.

The large number of copies made from some statues took their toll on them: In one of his dialogues, Lucian mentions how a statue of Hermes on the agora in Athens had become blackened from all the molds taken.[97] The Roman purchasers did not regard the works they bought as inferior copies but rather as legitimate substitutes for the unavailable originals to which they were linked through their shared iconographic type.[98] It should be remembered in this context that the Romans were not the first to produce copies and variations of statues. Replicas had already been made during the classical period, for example when filial cults were established[99] or when cult images of gods had to be replaced after being destroyed by fire. From the Hellenistic period onwards, originals and copies were often placed indiscriminately beside each other, and ancient written sources do not explicitly distinguish between the two.

Repetition, Variation and Innovation: The Roman Taste for Copies

Modern scholars have often struggled with Roman copies, since they tend to see the creation of an artwork as a one-off "performance" that cannot be repeated. But the value accorded to these replicas has changed over time. Copies and adaptations were long considered derivative and inferior, and were appreciated primarily as useful evidence for reconstructing the largely lost Greek originals. However, recent research under the more or less conscious influence of postmodern and postcolonial approaches has sought to emphasize their creative achievement and to appreciate them in their new Roman context and functions. The ground for this reevaluation had been laid by the discovery of so-called classicistic statues—works that draw on classical Greek styles but constitute independent, albeit eclectic Roman creations.[100] Apart from copies replicating the original as faithfully as possible,

there existed various degrees of appropriation, from slight variants to completely free adaptations and new creations that were only loosely inspired by Greek models of various periods. Accordingly, not every Roman ideal statue has a Greek prototype. A good example of this is the statue of Dionysus with Nebris and Panther (cat. 13).[101] Its contrapposto and elongated body are modeled on fourth-century statues (or on a Hellenistic interpretation of such late classical models), but in this specific form the Dresden statue of Dionysus, clasping his drinking vessel and acting as the bringer of pleasure and intoxication, is probably Roman in its conception. Assessments of such statues vary. Some scholars cite them as evidence of the creative recombination of Greek formal elements in Roman art, or have even interpreted them as competitive new creations through which the Romans asserted their own distinct cultural identity, separate to that of the Greeks.[102] Yet it is undeniable that these "classicistic" works remain very much indebted to the traditional Greek formal repertory, even if their combination of individual elements is often innovative. The sculptors of antiquity may have seen them as cautious "improvements" or "updates" of their Greek models, which were a better match for the tastes

and intentions of Roman purchasers than the classical Greek originals, often considered overly severe and austere. Depending on a statue's function and intended message, artists chose archaic, classical, or Hellenistic forms.[103] The Romans thus continued drawing on a visual language which was already several hundred years old by the time copying reached its zenith in the second century CE, and not always ideally suited to the social values and norms of Roman life.

The journey from original to copy often involved a change in material, scale, and context. Greek originals such as the Athena Lemnia were often—though not always—made of bronze, a material that seemed particularly well suited for the complex compositions full of movement created by early classical sculptors. By contrast, Roman copies were usually made of marble. Consequently, the artistic processes involved differed considerably: Marble statues were chiseled from raw blocks, while the creation of a bronze statue required a wax or clay model. Copies of statues made of gold and ivory or of acrolith (a combination of wood and marble) did not usually adopt the originals' complex piecing technique. Since marble lacked the tensile strength of bronze, struts and structural supports had to be added to the marble copies. A good example of this is the Dresden Artemis, where a support has been inserted below the raised right arm (cat. 6).[104] Some of these supports are so conspicuous that it has been suggested that their copyists sought to draw attention to their particular diligence, skill, or fidelity to the original. This assumption is further supported by the fact that in some sculptures the points of measurements required to produce accurate copies were deliberately retained.

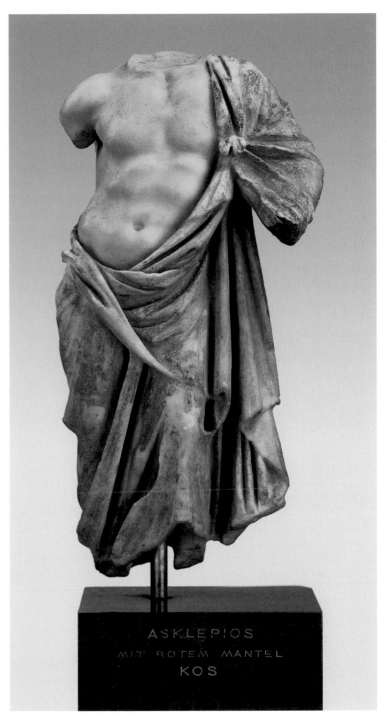

11 *Statuette of Asklepios*, 150–100 BCE, copy after a model from the mid-fourth century BCE, Skulpturensammlung, Staatliche Kunstsammlungen Dresden

The production of copies and versions often brought about a change in scale. Many Greek statues, such as the Aphrodite Louvre-Naples type, also known as Aphrodite Fréjus,[105] survive in replicas of various sizes, from larger-than-life marble copies to small statuettes or terracotta statues. Even Pheidias's monumental statue of the

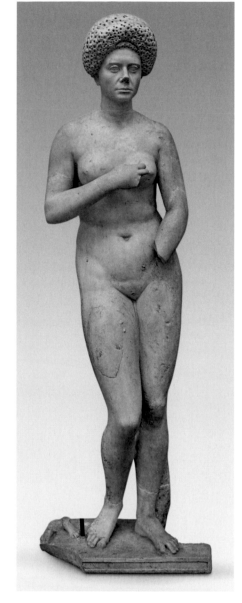

12 *Portrait Statue (so-called Marcia Furnilla) in the Type of the Capitoline Aphrodite,* late first century CE, Ny Carlsberg Glyptotek, Copenhagen

Athena Parthenos (fig. 2) was copied as a statuette.[106] At a mere 1.28 meters, the Dresden statue of the Apollo Lyceus (cat. 5) does not reflect the original's size; the Lycean Apollo in the Louvre, which is probably the most reliable copy of this type, is over two meters tall.

Cultured Leisure:
Greek Images of Gods in the Roman Era

From Greek to Roman times, the changing contexts in which statues were displayed were particularly significant. While the Greeks usually erected their statues in urban public places like sanctuaries, temples, and political centers (*agorai*), Roman copies and versions of Greek sculpture were mostly shown in the semiprivate contexts of houses and villas and their surrounding parks and gardens. It was not until the imperial period that the emperor's patronage made original works, copies, and adaptations accessible in public buildings. New contexts often also altered the sculptures' function. In its Roman setting, the small Lateran-type Poseidon thus became a fountain statue (cat. 7).[107] Leaning on his tripod in a stance suggesting power and authority (he may have held part of a ship's stern [*aphlaston*] in his right hand), the god of the seas surveying his realm became a mythological reference that ennobled the fountain it adorned.

Like other examples of this type, the statue of the Muse Thalia (cat. 1) may have formed part of a group of Muses marking out a Roman villa as a place of Greek culture and leisure (*otium*);[108] or perhaps it was displayed in a nymphaeum, public bathhouse, or theater (either in a public place or set in the landscape surrounding a villa, like that of Hadrian's villa at Tivoli). The Muse of comedy expressed the patron's love of theatrical entertainment; the comedies of the Greek poet Menander, for example, continued to enjoy great popularity in Roman times. Another fashionable leisure activity pursued by both men and women during the late republic and empire was writing poetry. Statues of Muses thus evoked the kind of nonutilitarian knowledge through which the social elite defined and expressed itself. As the antithesis of the world of public affairs and business (*negotium*), the villa was a place where Romans could indulge in (mainly Greek) literature, philosophy, and poetry, dress in the Greek fashion, and—if they were wealthy enough—surround themselves with Greek tutors, musicians, actors, and philosophers. The Muse's body language befits this context: The relaxed yet supremely elegant pose exudes something of the carefree mood that such statues were meant to convey to the viewer.

This initial reception of Greek art in the private world of the villa defined the manner in which the Romans subsequently appropriated and interpreted Greek models. In their Roman contexts, the Greek myths and artworks were used to articulate private sentiments, physical qualities and personal relations, and this would carry on throughout the imperial period. Portrait statues combining heads of Roman men and women with bodies of mythical gods and heroes played a similar role.[109] Even though in principle any deity's body could be chosen for these sculptures, artists carefully selected a fitting match, for example portraying young women in the guise of Artemis, and young men as Hermes. The statuary types of Zeus/Jupiter, the father of the gods, were reserved for the Roman emperor, a privilege that illustrated his unique power (which was not clearly defined in constitutional terms). During Flavian times, the type of the Capitoline Aphrodite became popular for funerary statues of women (fig. 12). Derived from Praxiteles's Aphrodite of Knidos, this statue type expressed the new kind of

sensual awareness and passionate openness in marital relationships that was celebrated in the elegiac verses of the contemporary poet Sulpicia Caleni (whose work is unfortunately almost entirely lost today).

The late classical statuary type thus became the vehicle for certain "emancipatory"[110] developments of the imperial period. Much the same applies to the so-called *concordia* groups, which combined a portrait statue of the Ares Borghese type with one of the female Capua-type Aphrodite (fig. 13).[111] The reference to the romantic relationship between these two Olympian gods was obviously seen as an appropriate way of extolling the emotional bond portrayed between the couple. Here, the creative achievement lies in the combination of Greek statuary types from different periods, which radically reinterprets the figures' gestures. The torso fragment of the Dresden Ares Borghese, later reworked into a bust (cat. 12), originally formed part of such a group, although it did not bear a portrait.

The style of most of the exhibited sculptures identifies them as works of the first and second centuries CE, a time of political stability and economic prosperity. But even in the late fourth century CE, when the majority of the Roman Empire's population was already Christian, statues of gods continued to be produced, serving the antiquarian interests of an elite that was both educated and nostalgic.[112] The Demeter statue of the Poggio Imperiale type (cat. 9) is one such small-scale sculpture that probably once adorned a late antique villa near Rome as part of a group.[113] Other statues from the same group that have survived show Apollo and Artemis (cat. 34); a headless

armored statue may have depicted Alexander the Great and his horse Bucephalus. Demeter's opulent clothing and wreath of braided ears of corn mark her as the matronly goddess of fertility and prosperity. With her left hand she holds a bunch of poppies and gathers up her cloak, while her right hand once rested on a large torch. During the imperial period, this popular type was often used for portrait statues of female members of the imperial household, evoking their role as guarantors of dynastic continuity.

Displaying all the typical characteristics of the late antique style, the Dresden Demeter statue differs markedly from versions of the same type from the early and mid-imperial periods. The figure's flat frontality draws the viewer's eye to the goddess's paraphernalia and attributes which are spread out conspicuously, providing an almost didactic explanation of its mythological nature and function. The surface is polished like ivory; we do not know to what extent this impression was muted by the statue's original polychromy. The deeply drilled eyes lend a particular intensity to the goddess's gaze; in figures of this kind, face and hands are generally enlarged and thus accentuate gestures and facial expressions. The mannered drapery of Demeter's garments reflects the highly stylized, artificial, and ceremonial nature of social life in late antiquity.

These late antique statues of gods close the circle: They evoke the

Olympian deities as nothing more than learned mythological references. The pagan gods and their myths have entered a canon which will be studied by many including the Church Fathers and Christian theologians. What has receded into the shadows is not just the religious and cultic dimension of these images, but also the immediate, sensual presence that once connected the statues of earlier days with the lived experience of those who beheld them.

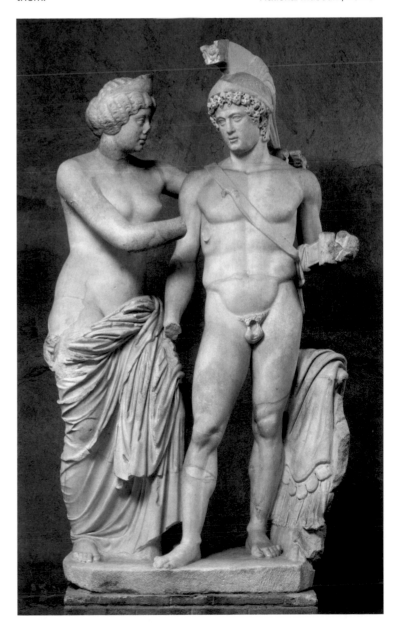

13 *So-Called Concordia Group from Ostia: Ares Borghese and Aphrodite of Capua With Portrait Heads*, second century CE, National Museum, Rome

1 For what follows, see esp. Sissa/Detienne 2000; also Simon 1985; Veyne 1988; Graf 1991; Buxton 1994; Vernant 2001; Whitmarsh 2015.

2 Homer, *Iliad* 8.393–95.

3 Vernant 2001, 3–13.

4 Buxton 1994, 82 incl. note 7 (on Aristotle, *Politeia* 1330b).

5 Homer, *Iliad* 8.2–29.

6 Scodel 2017.

7 Veyne 1988.

8 For what follows, see esp. (includes further references): Scheer 2000; Steiner 2001; Bremmer 2012; Chaniotis 2017; F. Hölscher 2017.

9 Scheer 2000; Steiner 2001, 19–22; F. Hölscher 2017, 43–86. On the gods' presence during sacrifices, see Sissa/Detienne 2000, 176–78.

10 Bremmer 2012.

11 Alcaeus, *Fragments* 298.20–27; see Bremmer 2012, 9.

12 The debate on the distinction between cult images and votive offerings and the ontological quality of statues of the gods is summarized by F. Hölscher 2017 (includes further references).

13 DNO, XX–XXV.

14 F. Hölscher 2017, 65–146, and passim.

15 Bremmer 2012; Chaniotis 2017, 149.

16 Bremmer 2012, 13–14.

17 Bonn 1989; Zanker 2005; see Bremmer 2012, 15.

18 F. Hölscher 2017, 171–75.

19 Bremmer 2012, 11.

20 Alcaeus, *Fragments* 298.20–27; see Bremmer 2012, 8.

21 E.g. Pausanias 3.15.7; F. Hölscher 2017, 148–71.

22 Stewart 2016, 595–98.

23 Agnoli 2002, p. 263–72.

24 Herodotus, *Histories* 5.82–86; see Bremmer 2012, 10.

25 Pausanias 6.11.2–6; Dion Chrysostomos, *Oratio* 31.95–97.

26 E.g. Hölscher 2007, 10; Bremmer 2012, 12; Chaniotis 2017.

27 Adolf Heinrich Borbein, "Klassische Kunst," in Berlin 2002, 9–25. For what follows, see esp. Pollitt 1972; also Pascal Weitmann, "Götterbild und Götternähe im Spiegel der Entwicklung klassischer griechischer Kultur," in Berlin 2002, 82–93; Tanner 2006; Stewart 2008; Neer 2010; T. Hölscher 2017. See also contributions in two exhibition catalogs on Greek classicism: Berlin 2002; Frankfurt 2013.

28 Clements 2016.

29 Pollitt 1972, 99.

30 Evelyn B. Harrison, "Pheidias," in Palagia/Pollitt 1998, 16–65, here 31.

31 On the significance of *thauma* see esp. Neer 2010, 57–69.

32 Dresden Bildwerke II, cat. 2; Berlin 1994, 182–84; Neumann 2004; T. Hölscher 2017, 122–26.

33 Pollitt 1972, 48, in reference to a fragmented statue of Athena in the Metropolitan Museum of Art in New York.

34 T. Hölscher 2017, 104–10.

35 Pausanias 1.28.2. Quoted here from *Pausanias*, trans. W.H.S. Jones and H.A. Ormerod (Cambridge, MA: Harvard University Press, 1918). For the sources see DNO, vol. 2, 165–71; also Steiner 2001, 102. Adolf Furtwängler's aesthetically pleasing reconstruction is controversial; not even the attribution of the work to Pheidias, who produced many further statues of Athena, has been universally accepted. See e.g. Harrison 1998 (see note 30), 64; or the summary in *Dresden Bildwerke II*, cat. 2, 130: "Thus the sources do not allow us to accurately date the dedication of the Athena Lemnia or to know the occasion of that dedication."

36 T. Hölscher 2017, 137–38.

37 Dresden Bildwerke II, cat. 95.

38 Ostwald 1995, 50; Mikalson 2003; Raaflaub 2004, 108–17.

39 Raaflaub 2004, 108–09. The cult of Zeus Eleutherios is mentioned by Herodotus as appearing on Samos as early as the late sixth century BCE, but according to Raaflaub it is "not an authentic tradition but a historicizing fiction," or an erroneous interpretation of a slightly later cult, Raaflaub 2004, 110–11.

40 Dresden Bildwerke II, cat. 113; DNO, vol. 2, 362–64, no. 5; Stewart 2016; critically summarized in F. Hölscher 2017, 526–34.

41 Pausanias 1.8.4.

42 Stewart 2016, 601–21; see F. Hölscher 2017, 533–34.

43 Pollitt 1972, 111–35; Stewart 2008, 191–227.

44 Pollitt 1972, 125–35.

45 Homer, *Iliad* 21.462–66.

46 F. Hölscher 2017, 539.

47 Klaus Junker, "Die Athena-Marsyas-Gruppe des Myron. Götter als 'Erste Erfinder,'" in Berlin 2002, 519–23; Junker 2012.

48 T. Hölscher 2017, 142–45, quote on p. 142.

49 Dresden Bildwerke II, cat. 122; see F. Hölscher 2017, 554–61.

50 Lucian, *Anacharsis* 7. Quoted here from "Dialogues of the Gods: Hermes and Maia," in *Soloecista. Lucius or The Ass. Amores. Halcyon. Demosthenes. Podagra. Ocypus. Cyniscus. Philopatris. Charidemus. Nero*, trans. M. D. MacLeod (Cambridge, MA: Harvard University Press, 1967).

51 Burckhardt 1998, 330.

52 Pollitt 1972, 136–94.

53 E.g. Buchheim 1986; for a recent summary see Scholz 2006, 38–43.

54 Dunbabin 1999.

55 Fabricius 2001; Bernhardt 2003.

56 Pollitt 1972, 125, 159; see Stewart 2008, 191–211.

57 Rainer Maria Rilke. *Duino Elegies & The Sonnets to Orpheus*, trans. Stephen Mitchell (New York: Vintage International, 2010), 3.

58 For an overview (including earlier references) see Berlin 1994, 241–43; Havelock 1995; Aileen Ajootian, "Praxiteles," in Palagia/Pollitt 1998, 91–129, here 98–103; Stewart 2014, 177–84; Lee 2015; F. Hölscher 2017, 549–54.

59 Stewart 2010 (includes further references); Stewart 2014, 177–84.

60 Dresden Bildwerke II, cat. 33.

61 Esp. Pliny the Elder, *Naturalis historia* 36.20.

62 Athenaeus, *Deipnosophistai* 13.590.

63 F. Hölscher 2017, 65 (on Kallimachos, *Hymnos* 5.51–54).

64 See e.g. Stewart 1997; Hölscher 1998; Stähli 2001; Hölscher 2003.

65 Xenophon, *Agesilaus* 1.28; Hölscher 1998, 46.

66 Hölscher 1998, 55; Hölscher 2003.

67 Stewart 1997.

68 For such a "relational" understanding of images of Greek bodies see esp. Fabricius 2001; Fabricius 2007.

69 Foucault 1985, 149–51.

70 Lee 2015.

71 Stewart 2010; Stewart 2014.

72 Pliny the Elder, *Naturalis historia* 36.20.

73 Hölscher 1998, 49–50.

74 Pausanias 1.19.2.

75 Pollitt 1972, 159–60.

76 Stewart 2008, 202.

77 See Fabricius 2001; Fabricius 2007.

78 For the written sources see Oliver Primavesi, "Colorful Sculptures in Ancient Literature? The Textual Evidence Revisited," in Munich 2007, 192–209.

79 Pliny the Elder, *Naturalis historia* 35.133.

80 Liverani 2010.

81 Elena Walter-Karydi, "The Coloring of the Relief Background in Archaic and Classical Greek Sculpture," in Munich 2007, 172–77.

82 Vinzenz Brinkmann, "Colors and Painting Techniques," in Munich 2007, 210–15; Ulderico Santamaria und Fabio Morresi, "Die naturwissenschaftlichen Untersuchungen zur Farbigkeit des Augustus von Prima Porta," in Hamburg 2007, 218–21.

83 Ulrike Koch-Brinkmann and Richard Posamentir, "The Grave Stele of Paramythion," in Munich 2007, 132–40; here 137: "The first brush stroke showed the experimenters why marble was regarded in antiquity as an ideal ground for painting. The surface is absorbent enough to receive the colors without any blurring of the texture but at the same time is compact enough for the pigment to exhibit its full color immediately. The various pigments thus produce a solid hue, but, nonetheless reveal the surface structure of the marble. The only exceptions are blue and green mineral pigments, which form a surface of their own according to how the color is applied."

84 Hermann Born, "… auch die Bronzen waren bunt …," in Hamburg 2007, 144–49; Raimund Wünsche, "On the Coloring of the Munich Bronze Head with a Victor's Fillet," in Munich 2007, 118–31; Edilberto Formigli, "Die Oberflächengestaltung antiker Großbronzen," in Frankfurt 2013, 274–88; Formigli, "Die Statue A von Riace und die technisch-formalen Grundlagen der frühklassischen Bronzeplastik," in Frankfurt 2013, 265–67.

85 Wünsche 2007 (see note 84), 153–54; Frankfurt 2013.

86 Dresden Bildwerke I, cat. 50.

87 Dresden Bildwerke II, cat. 133.

88 Neer 2010, 74–77.

89 See Fabricius 2001.

90 Vinzenz Brinkmann, "Die nüchterne Farbigkeit der Parthenonskulpturen," in Hamburg 2007, 138–43, here 140.

91 For what follows see esp. Zanker 1974; Pollitt 1978; Ridgway 1984; Hölscher 1987; Cain 1998; Geominy 1999; Gazda 2002; Zanker 2002; Hallett 2005; Perry 2005; Trimble/Elsner 2006; Junker/Stähli 2008; Marvin 2008; Bartsch et. al. 2010.

92 Pollitt 1978.

93 Summarized in Zanker 2010, 1–47.

94 See the quantitative analysis in Pollitt 1978, 157–58.

95 Summarized in Zanker 2010, 1–47.

96 Landwehr 1985.

97 Lucian, *Jupiter Tragoedus* 33.

98 For the important concept of "substitution," which has received little attention in classical archaeology, see Nagel/Wood 2005; Nagel/Wood 2010.

99 Gaifman 2006.

100 Zanker 1974.

101 Dresden Bildwerke II, cat. 133.

102 Perry 2005; see Hallett 2005.

103 Hölscher 1987; Zanker 2007, 27–32.

104 Dresden Bildwerke II, cat. 15.

105 Brinke 1991.

106 Naumann-Stecker 2015.

107 Dresden Bildwerke II, cat. 97.

108 Dresden Bildwerke II, cat. 59.

109 Wrede 1981; Ewald 2008; Annetta Alexandridis, "Mimesis oder Metapher? Aphroditekörper im römischen Frauenporträt," in Boschung/Jäger 2014, 67–102.

110 Wrede 1971; Ewald 2008; Alexandridis 2014 (see note 109).

111 Kousser 2007; Jens Daehner, "Faustinas Liebhaber. Vom Mythenbild zur historischen Fiktion," in Boschung/Jäger 2014, 295–320.

112 Stirling 2005; Kristensen/Stirling 2016.

113 Dresden Bildwerke II, cat. 138.

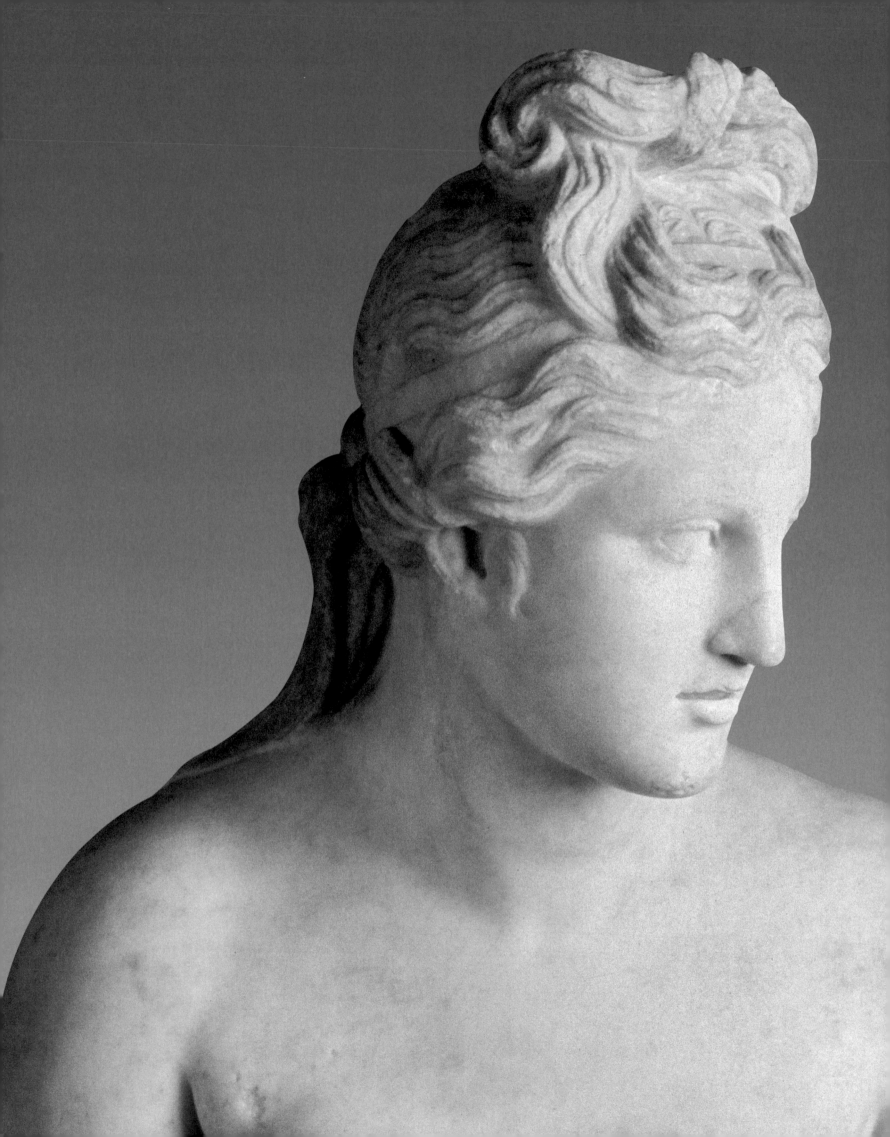

Let us begin our singing
from the Helikonian Muses
who possess the great and holy mountain
of Helikon
and dance there on soft feet
by the dark blue water
of the spring, and by the altar
of the powerful son of Kronos; [...]
and walk in the night, singing
in sweet voices, and celebrating
Zeus, the holder of the aegis, and Hera,
his lady
of Argos, who treads on golden sandals,
and singing also
Athene the gray-eyed, daughter of Zeus
of the aegis,
Phoibos Apollo, and Artemis
of the showering arrows,
Poseidon who encircles the earth in his arms
and shakes it,
stately Themis, and Aphrodite
of the fluttering eyelids, [...]
and all the holy rest of the everlasting
immortals.

Hesiod, *Theogony* 1–21

The Muses, Sweet-Voiced Daughters of Zeus

1 *Seated Statue of a Muse, So-Called Thalia*
10–50 CE, copy after Roman originals from the later second century BCE
Fine-grained white marble, height 116 cm
Acquired circa 1727–29 from the collection of the marchese Nari, Rome
Inv. no. Hm 188
Lit.: Dresden Bildwerke II, cat. 59

We talk of being "kissed by the Muse" to describe a sudden burst of inspiration (from the Latin *inspirare*, which means "to blow or breathe into"). Musicians, writers, film directors, fashion designers, and other creatives are often also captivated by their own earthly incarnations of these Muses and notoriously fond of the kisses they may bestow. In antiquity, creativity was a divine attribute, and the Muses were the patron goddesses of the arts and sciences.

They were the daughters of Zeus, who had fathered them in nine consecutive nights, and Mnemosyne, the Titan goddess of memory. Some writers believed that the Muses lived on Mount Olympus, while others favored Mount Helicon or Mount Parnassus as their home. Originally goddesses of vegetation, fertility, and water, with no fixed number or function, they are closely related to other creatures associated with nature, like the horae, nymphs, or charites. Hesiod was the first to state the names of nine individual Muses, and this account was soon widely accepted. Although the personalities and domains of individual Muses were gradually differentiated throughout the Greco-Roman era, and a tendency towards allegory can first be observed at this time, it was only in the early modern period that the Muses came to personify individual arts, and their functions were clearly specified by their attributes.

Calliope, the "fair-voiced," is the highest ranking of the Muses. As the Muse of epic poetry, she is often portrayed with a scroll or writing tablet in her hand. Clio, the Muse of history, frequently carries a scroll too. Melpomene, the Muse of tragedy, is represented with a tragic theater mask, while her sister Thalia (also spelled Thaleia) (cat. 15), in charge of comedy, is usually seen with a comic mask. Euterpe, the Muse of flute playing (cat. 16), is depicted with a flute in her hand. Erato's domain is love poetry, which she accompanies on the lyre or kithara (cat. 17, 18). Terpsichore ("she who delights in dancing") also plays the lyre or the flute and is responsible for choral singing and dance (cat. 19). Urania, with a globe in her hand, is the patron goddess of astronomy. Pol(h)ymnia ("the one of many hymns") (cat. 20), who can often be seen deep in contemplation and without attribute, is the only one whose functions have remained ambivalent—depending on the author, she is assigned to poetry, history, sacred music, or mime.

The gracious young women (cat. 21) with the beautiful voices, who, according to Hesiod, sing about all the gods, "the everlasting immortals,"[1] were not just carefree goddesses of song, dance, and music. Their task was to inculcate humans with knowledge and convincing eloquence. In a time when knowledge was transmitted orally, memory played a crucial role, and what interested people even more than history were stories: tales that people could remember and which were passed down by singers and poets. It was creative, musical, and intellectual abilities like these that the Muses provided, for they were the ones who sang "of what is, and what is to be, / and what was before now,"[2] as Hesiod tells us.

The nine daughters of Zeus are usually represented as charming, often garlanded young women, clothed in luxurious fabrics which reveal the outlines of their bodies. Seated or standing, they hold their instruments in their hands. They can be found in all genres of art, although the nine sisters are not always represented together. Single statues of Muses or group compositions from the Roman imperial period like the ones in Dresden were mostly placed in villas, gardens, theaters, or thermae. They imbued these sites with an aura of learnedness and artistic refinement that invited local people and visitors alike to philosophize, to engage in creative activity, or to simply enjoy themselves. *SW*

1 Hesiod, *Theogony* 22. *The Works and Days, Theogony, The Shield of Herakles*, trans. Richard Lattimore (Ann Arbor: University of Michigan Press, 1959).
2 Hesiod, *Theogony* 38.

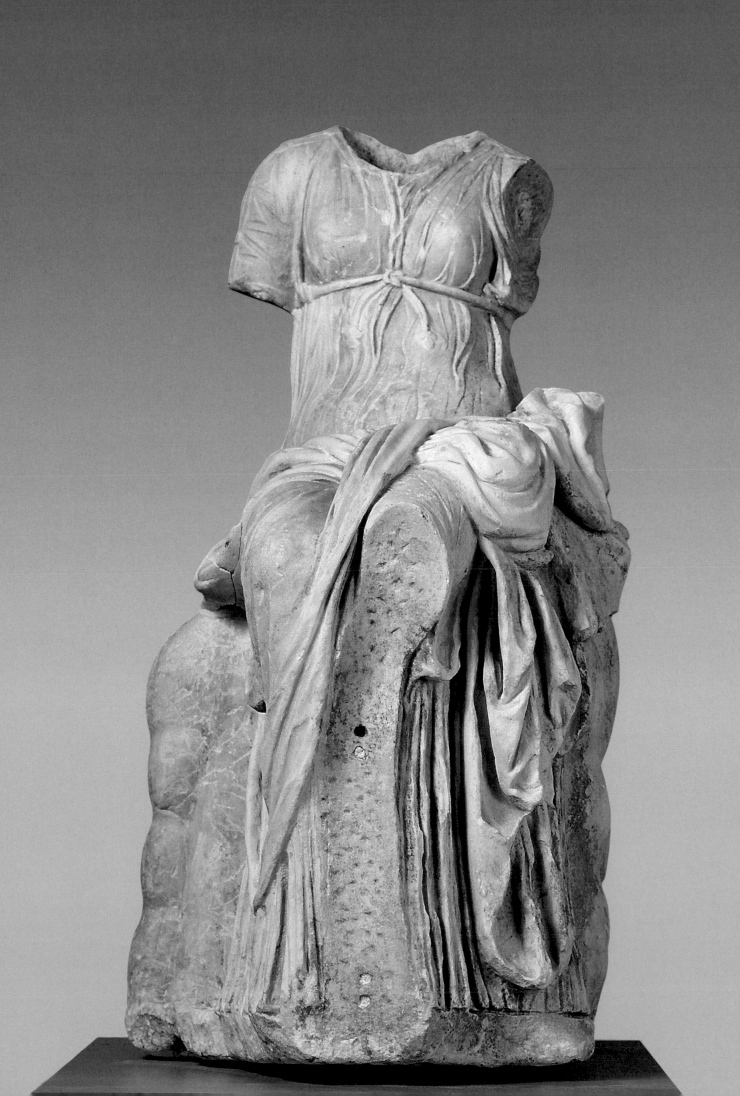

Zeus, King of the Gods

2 Statue of Zeus, so-called Dresden Zeus

120–130 BCE, after an original by Pheidias and/or his circle circa 430–420 BCE
Fine-grained white marble, height 197.5 cm
Acquired in 1728 from the collection of Alessandro Albani, Rome
Inv. no. Hm 68
Lit.: Dresden Bildwerke II, cat. 95

According to Greek mythology, the all-powerful Zeus ruled over heaven and earth. The son of the Titans Kronos and Rhea, he was also known as Cronides. After toppling his own father from his divine throne with the help of his mother, just as his father had done before, he became the leader of a new generation of deities—the Olympian gods. With his legitimate wife Hera, who was also his sister, he resided, according to Hesiod, as the "King of the gods"[1] high up on Mount Olympus, the mountain of the gods on the eastern coast of Greece. From there he observed what happened on earth and prudently directed the fortunes of the world.

The symbols of his supreme power are the eagle, the thunderbolt, and the scepter. As god of thunder and lightning, Zeus ruled over the weather, which is why he was also known as "god of the dark cloud" or "cloud-gatherer". Vast shrines in Olympia, Athens, Dodona, and Pergamon were dedicated to this most Panhellenic of all the Greek deities. The long list of his epithets reveals the many functions ascribed to him by local cults. Although married to Hera, Zeus was a notorious philanderer who had countless affairs with beautiful young women, daughters of kings, nymphs, and nereids. These more or less consensual alliances produced numerous children who were either gods or demigods. To escape his wife's jealous watch, Zeus cunningly used his powers of transformation to seduce his chosen conquests. He approached the Phoenician princess Europa in the form of a bull (cat. 22); beguiled Leda, the daughter of the king of Aetolia, in the guise of a swan; appeared to Danae as golden rain; and ensnared Mnemosyne, the goddess of memory, disguised as a shepherd. To lure the nymph Kallisto, he turned himself into the hunting goddess Artemis.

The amorous adventures of this protean god were popular themes in Greek vase painting, while sculptures usually presented him as a bearded, curly locked, virile man of imposing stature. The most astounding of these was the colossal seated figure of Zeus at Olympia by the Attic sculptor Pheidias. The twelve-meter-high statue adorned with ivory and gold showed the enthroned father of the gods holding the goddess of victory Nike in his right hand and a scepter and an eagle in his left. It is now considered to be one of the Seven Wonders of the Ancient World. Whether they represent him with a thunderbolt, scepter, or spear; standing, walking, or seated; fully or partially clothed or completely naked, statues of Zeus invariably focus on the male physique as an expression of omnipotence. The Dresden Zeus is no exception. A thick mass of long, curly hair and a full beard impart a sense of stately and dignified age (cat. 23). The broad, bare chest, the powerful shoulders, and the upright posture are reminiscent of the depiction of Attic citizens on the frieze of the Parthenon (447–432 BCE) on the Athenian Acropolis, whose creation was also supervised by Pheidias.

The Dresden statue is probably a copy of an original from the circle of this sculptor. It does not just represent an all-powerful god but also reflects the intention of the Roman copyist to remind his audience of the artistic production of a glorious past.

But the authoritarian and awe-inspiring father of all gods and humans had another side: His extramarital affairs provided Greek comedy writers with plenty of material and opportunities for parody. Taking the myth down from Olympus and setting it in ordinary, everyday life, these writers presented Zeus as a rather chauvinistic patriarch with a marked penchant for young women. He thus became a perfect model for autocratic rulers of one kind or another—and not only in antiquity.
SW

[1] Hesiod, *Theogony* 886.

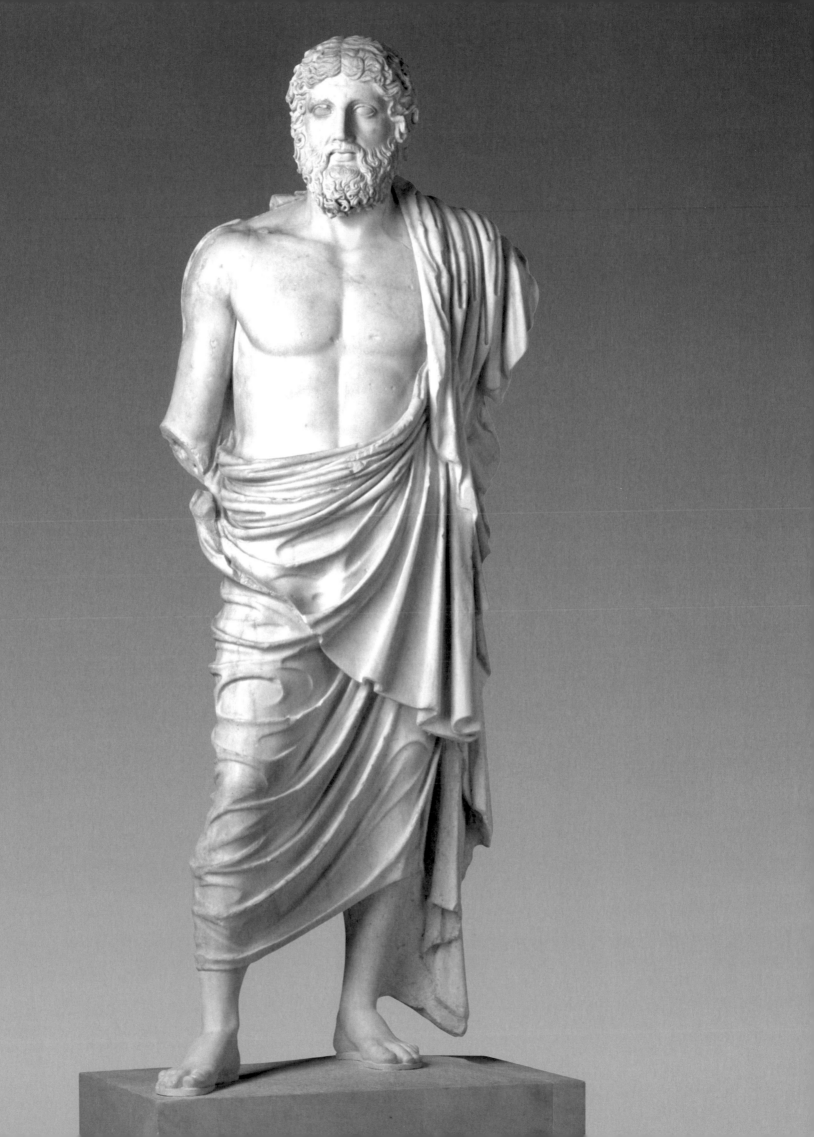

Hera, Queen of the Gods

3 *Hera and Zeus*
Partial cast of the Puteal of the Twelve Gods (Albani Puteal), Rome, Capitoline Museums
Before 1857, after an original from the first half of the second century CE
Plaster, height 50.5 cm
Acquired before 1857
Inv. no. ASN 2938
Lit.: Hettner 1857, no. 27

"Jealousy is a grievous passion that jealously seeks what causes grief," the playwright Franz Grillparzer once noted. Today, the destructive nature of jealousy that he described is a subject that fills a host of self-help books and keeps couple's therapists in business. Almost everybody is familiar with jealousy's power, and in antiquity gods and mortals were not immune to it either. Hera's jealous nature was legendary. Daughter of Rhea and Kronos, she was Zeus's sister and consort. Although her relationship with the father of the gods may not have been perfect, she was the embodiment of the respectable wife and therefore regarded as the patron deity of married women. Her union with Zeus produced Ares, the god of war, Hephaestus, the god of blacksmiths, Eileithyia, the goddess of childbirth, and Hebe, the goddess of youth. Hera, Zeus's "blooming wife," was enthroned next to her divine consort on Mount Olympus,[1] where she was honored by gods and venerated by pious humans (cat. 24, 25). Her cult reflects the public image and importance of women in the society of ancient Greece. She kept a benevolent eye on married couples, wives, and offspring, but also on cities and their young male citizens. Hera's most important center of worship was in Argos and the surrounding region in the northeastern Peloponnese. The festival celebrated in her honor there, known as the Heraia, and the Heraion of Argos, the greatest shrine dedicated to Hera, played an important part in her cult. In the second century, the Greek traveler and geographer Pausanias described a statue of Hera in the temple, created in ivory and gold by the Argive sculptor Polykleitos. The enthroned goddess wore a crown and held a pomegranate in one hand and a scepter in the other. A cuckoo topped the scepter, symbolizing the form that Zeus had once taken when he courted the virgin Hera.

This statue has not survived, and only very few other single-figure representations of the goddess are known. Hera was represented draped in a voluminous peplos and himation, with her hair modestly veiled—the ideal of the Greek consort and housewife, and the embodiment of grace and dignity. Homer describes her great beauty and calls her "ox-eyed," referring to her large eyes—a desirable facial feature to this day.[2] Hera is more frequently represented together with her husband Zeus, as for example in the eastern frieze of the Parthenon, or on the Puteal of the Twelve Gods in the Capitoline Museums in Rome, where she can be seen walking respectfully behind the thunder god, gracefully lifting her veil. It is rare in Greek mythology to find Olympian gods— let alone Hera and Zeus—in as much harmony as in the depiction on this marble wellhead.

There are many stories about Zeus's extramarital affairs with beautiful mortals or beguiling goddesses. Hera's justified jealousy of her competitors Alcmene, Semele, Leto, Kallisto, and others, as well as the vengeful wrath she directed upon their innocent children Heracles, Dionysus, Apollo, Arcas, and many others, repeatedly led to dramatic scenes on Mount Olympus and on earth. One of Zeus's love interests was the princess Io, whose fate Hera sealed with her unbridled fury. Zeus had cast an eye on the beautiful young woman and keenly pursued her. When his long-suffering wife got wise to his scheme, Zeus transformed Io into a cow. Not placated so easily, Hera demanded that her husband give her the animal as a present. And to be on the safe side, she had the cow guarded by the herdsman Argus with his hundred eyes. Io deplored her fate, and when Zeus could not endure her suffering any longer, he sent his son Hermes to kill Argus. The messenger of the gods lulled the watchman to sleep with flute-playing and stories, so that he closed every one of his eyes. Hermes then slew him with a stone. To commemorate her faithful watchman, Hera placed his eyes in the tail of the peacock, which became her favorite bird and companion.

SW

[1] Hesiod, *Theogony*, 921.
[2] For example in Homer's *Iliad*, 1.551. Quoted here from *The Iliad of Homer*, trans. Richmond Lattimore (Chicago, IL: Chicago University Press, 1973).

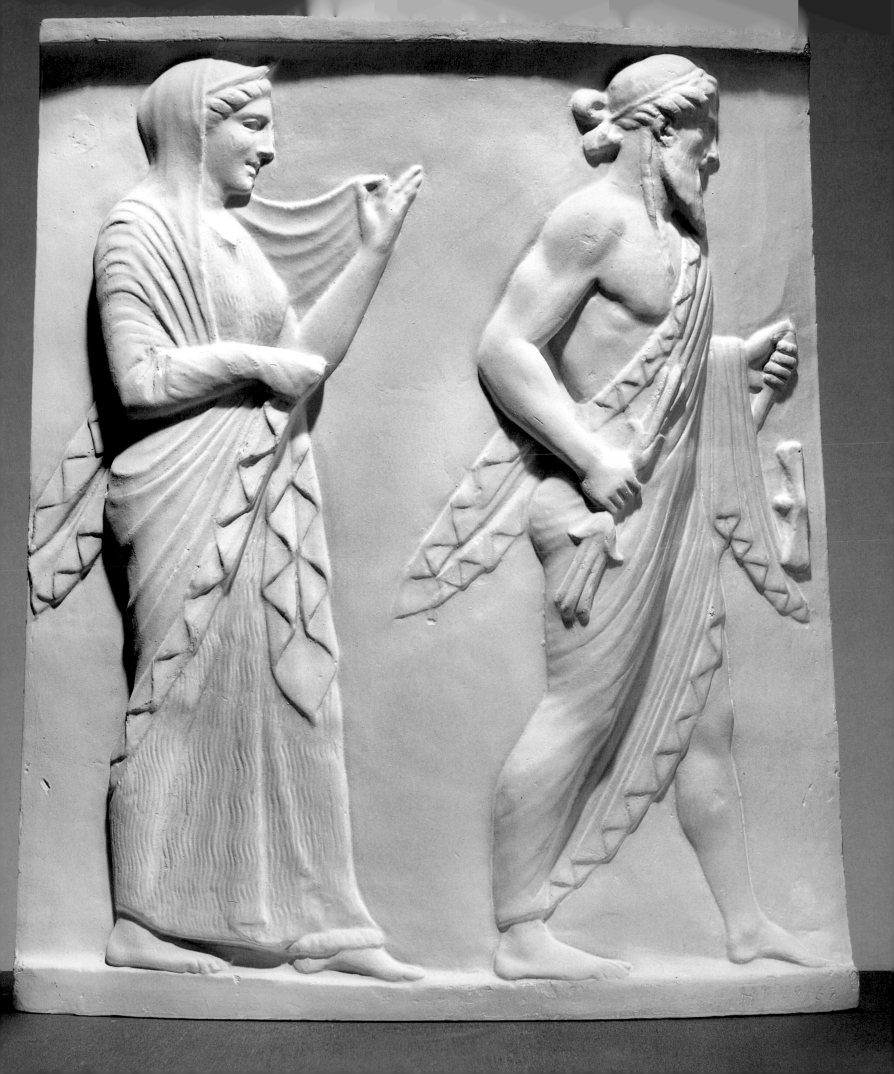

Athena, Owl-Eyed Guardian of the City

4 Statue of Athena, Dresden/Bologna Type, So-Called Athena Lemnia
Second quarter of the first century CE, after an original from circa 450–440 BCE
Pentelic marble, height 206 cm
Acquired in 1728 from the collection of Alessandro Albani, Rome
Inv. no. Hm 49
Lit.: Dresden Bildwerke II, cat. 2

Anyone who does creative work, whether sitting at a desk or practicing a craft, and anyone who fights for truth and justice, seeks fairness and compromise, or has attained wisdom, will find Athena well-disposed towards them. Zeus's favorite daughter is described as being "owl-eyed" (glaukopis) in the *Homeric Hymns*: "owl-eyed deity with crafty wisdom and steady heart / revered virgin, stalwart guardian of the city."[1] Her birth was miraculous. Since it had been prophesized to Zeus that Metis, Athena's mother, would bear another child who would overthrow him and rule over all the gods, he swiftly swallowed his pregnant wife. When the time for the birth had come, Hephaestus, the god of blacksmiths, was called, and he cleaved Zeus's forehead with a giant hammer. Athena miraculously emerged as a grown woman in full armor with helmet and spear. All those who witnessed the birth were awestruck by the charisma, stately appearance, and radiant beauty of Zeus's new daughter. The eastern pediment of the Parthenon on the Athenian Acropolis illustrates Athena's birth. This magnificently designed Greek temple from the middle of the fifth century BCE is dedicated to her, the virgin goddess of the city—the Greek *parthenios* means "virgin."
Athena had to fight for her rule over Athens, since Poseidon also laid claim to the Attic lands. Poseidon created a spring of salt water, Athena an olive tree. The Athenians considered the olive tree to be more useful, so that Athena emerged victorious, and along with the owl (cat. 26), the olive tree became one of her attributes. The western pediment of the Parthenon tells the story of this dispute.

Every four years, Athenians celebrated a festival in her honor, the Great Panathenaea. Apart from copious sacrifices, the statue of Athena in the temple on the Acropolis was given a new robe woven by the working maidens of the city. The festive procession of Athenians in the presence of the gods is illustrated on the Parthenon frieze. The Panathenaea included sports competitions during which the victor was presented with an amphora filled with oil, which showed the image of the armed goddess on one side and the victor's sport on the other (cat. 27).
Athena was active in many areas of life. As goddess for military strategy (Athena Promachos, "Athena who fights in the front line") and guardian of cities (Athena Polias) she had a martial aspect and was represented with helmet and spear. But she was also a popular, peace-loving goddess. As patron of the arts and crafts (Athena Ergane), she instructed her followers in a range of different skills, lending a hand whenever needed. As a manual worker and thus an early riser she was associated with the rooster, as can be seen on the Panathenaic amphorae (cat. 27). She was also said to have invented weaving and was depicted with spindle and spinning wheel. She helped carpenters in their labors. She watched over bronze and pottery workshops and invented the potter's wheel. Skilled in musical matters as well, she invented the flute, but, annoyed at the way her cheeks bulged when she played it, she threw it away. When Orestes came to Athens, pursued by the avenging Furies for the murder of his mother Klytemnestra, Athena granted him protection and supervised his trial by a jury of Athenians on the Areopagus. Through her judicious handling of the proceedings she placated the Furies; in the *Eumenides*, the last part of the *Oresteia*, Aeschylus gave Athena the casting vote in the judgment.

Athena's technical skills, her tenacity, energy, and courage, her moral values, intelligence, and prudence made her the goddess of wisdom. Around 440 BCE, Athenian colonists living on the island of Lemnos dedicated a bronze statue to the goddess of their home city. Said to have been of exquisite beauty, it was possibly created and signed by the famous sculptor Pheidias and stood amidst other votive offerings on the Acropolis. The original bronze statue is lost, but Roman marble copies have been preserved. One example is the so-called Athena Lemnia (also known as the Lemnian Athena). Now in the Dresden antiquities collection, it is one of the world's most famous representations of Athena. In this harmonious composition, Athena, dressed in an intricately rendered robe, exudes a calm and unassuming dignity. Her arms have not been preserved, but we can see that in her right hand she once held the helmet onto which she looks down, while her outstretched left hand rested on her spear—a gesture of peace.
The Romans called her Athena Minerva and venerated her as the goddess of wisdom, crafts, and the art of war. The female alabaster statue in the Dresden collection from around 120–140 CE, which probably represents Athena/Minerva (cat. 29), was once a cult idol in a palatial Roman villa.
KK

[1] *Homeric Hymns* 28.2–3. Quoted here from *The Homeric Hymns*, trans. Diane J. Rayor (Berkeley, CA et al: University of California Press, 2004).

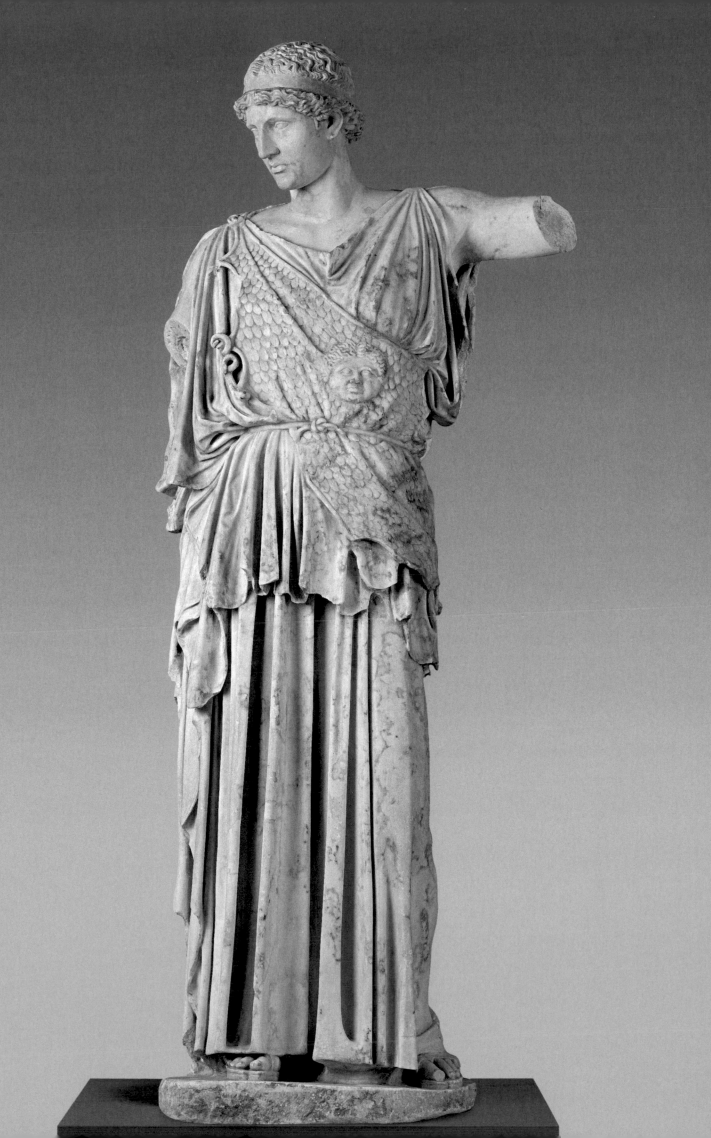

Apollo, a Joy for Mortals

5 Statue of Apollo, Apollo Lyceus Type
140–150 CE, after an original from the late fourth century BCE
Fine-grained white marble, height 128 cm
Acquired in 1728 from the collection of Alessandro Albani, Rome
Inv. no. Hm 127
Lit.: Dresden Bildwerke II, cat. 122

We may live in enlightened times, but fortune tellers and soothsayers are still in great demand. Many people hope to get a little help from astrologers, clairvoyants, cartomancers, or palm readers when faced with difficult decisions, urgent life choices, or intractable situations. Horoscopes are a feature in many magazines. On December 31, we may even become oracles ourselves: In Germany and some other European countries, people still employ molybdomancy. It uses the shapes formed by molten metals such as lead to predict the future, to find out what the New Year will bring.

In antiquity, the god Apollo was in charge of prophecy. As his epithet Phoibos ("shining") reveals, the ever-youthful son (cat. 30) of the powerful Zeus and the proud Leto was also the god of light, healing, music, and poetry. The *Homeric Hymns* celebrate him as "a joy for mortals."[1] He presided over the Muses and was a musician, accompanying his song on the kithara or lyre (cat. 31). As a courageous archer armed with bow and arrow, like his twin sister Artemis, goddess of the hunt (cat. 6, 33, 34), he punished evildoers.

When still a young man, Apollo slew a serpent at Delphi that had been terrorizing humans and animals. After he had fatally wounded the terrible beast with his arrows, the power of the sun god Helios caused its corpse to rot, and it was named Python ("decaying"). Apollo thus acquired the epithet Pythian, and the high priestess of the Oracle at Delphi became known as Pythia in his honor. His oracular shrine at Delphi was his most important sanctuary and renowned well beyond the borders of the Greek world, attracting visitors from near and far. As a vessel and inspired medium for the god's spirit, Pythia gave advice and warnings to those who consulted her. Of course we do not know whether she really sat on a tripod while receiving and delivering her counsel, but the Delphic tripod was the sacred symbol of divine prophecy.

The marble sculpture of the Dresden collection shows Apollo leaning nonchalantly against a tall tripod with the Delphic Python coiled around it. In his left hand, he holds what has been preserved of his bow, while his right arm rests casually on his head. He is depicted as a beautiful boy: His long hair is tied into a topknot, a typical children's hairstyle, and the soft contours of his hairless body suggest his youth. This Roman statue from the middle of the second century CE is modelled on a work from the late fourth century BCE known as the Apollo Lyceus. According to the Greek satirist Lucian, it once stood in the Lykeion in Athens. It was there that Aristotle founded his famous school, and in the gymnasion, in which boys and ephebes trained body and mind, Apollo was venerated as an educator of young men.

Apollo was not lucky in love, whether the objects of his affections were male youths, girls, or women. He killed his lover, the Spartan prince Hyacinth, by mistake. Another lover, the youth Kyparissus, asked Apollo to turn him into a tree, and his wish was granted. The nymph Daphne, whom he ardently pursued, escaped his advances by asking her father to transform her into a laurel tree; in remembrance, Apollo thenceforth wore a laurel wreath on his head (cat. 32). His love affair with the Thessalian princess Koronis also came to a sad end when she was unfaithful while pregnant with their child; overcome with jealousy, he killed her with an arrow. He saved his baby son from her dying body and took him to the cave of the centaur Chiron to have him instructed in medicine.[2] Asklepios, as he was called, soon followed in his father's footsteps and was also venerated as a god of healing.
SW

[1] *Homeric Hymns* 3.27.
[2] Ovid, *Metamorphoses* 2.542–632. Quoted here from *The Metamorphoses of Ovid*. trans. Mary M. Innes (Harmondsworth: Penguin Books, 1955).

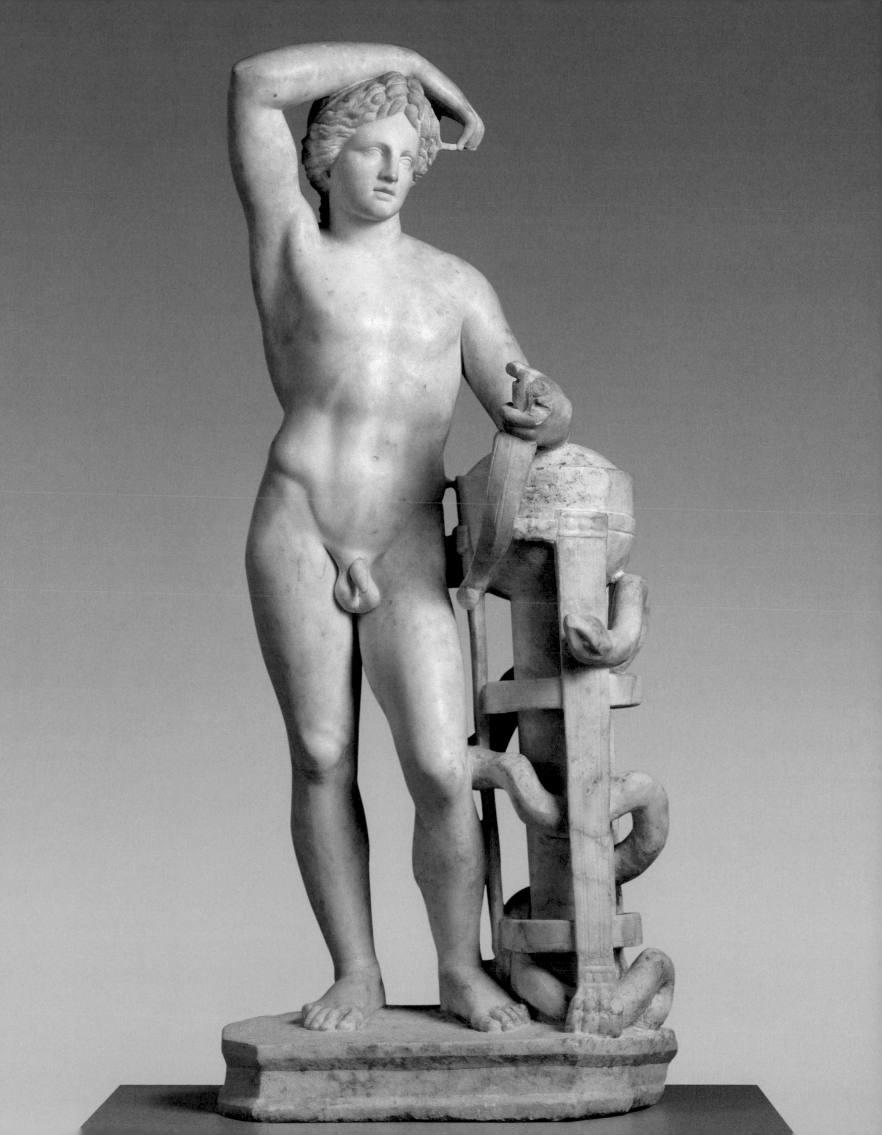

Artemis, the One Who Rains Arrows

6 *Statue of Artemis, So-Called Dresden Artemis*
Mid-second century CE, after an original from circa 360–350 BCE
Coarse-grained yellowish marble, height 152 cm
Acquired in 1728 from the collection of Alessandro Albani, Rome
Inv. no. Hm 117
Lit.: Dresden Bildwerke II, cat. 15

Although hunting has been a male domain for centuries, and to a large extent still is, the proportion of female hunters has been growing year on year in many European countries. Hunting in its current form as a sport fulfills a modern longing for the great outdoors, for self-experience and mindfulness, rather than primarily being a means of obtaining food. But it has also long been associated with elementary existential questions of life, death, and transience, which might explain why more and more women are becoming passionate hunters, and why even in antiquity hunting was linked with a female figure.

Artemis, goddess of the hunt, was born as the daughter of the great Zeus and the gentle Leto one day before her twin brother Apollo. Zeus's ever-jealous sister Hera, fearing she might lose power, had tried to prevent the birth of the two children by denying the pregnant Leto a place to deliver the babies anywhere in the world. But Leto eventually managed to give birth to the twins on Delos, a floating island in the Aegean. Apollo and Artemis remained forever associated with Delos, forming the Delian Triad with their mother, Leto.

Artemis was the mistress of animals and the protectress of good hunters. As "the one who rains arrows," according to the *Homeric Hymns*,[1] she roved the forests and mountains armed with her bow and arrow. Chaste and wary of men, she lived in the wilderness, accompanied only by virgin nymphs who served as her handmaidens. Her impudent and impulsive demeanor matched her role as patron of the young. She was the goddess of transitions—of childbirth, and especially of female initiation rites, but also of female death. She was also venerated as a goddess of the city, for example in Ephesus and Perga, and in this function as protectress of cities in the Hellenic East, she merged with the ancient Great Goddess of the region. The Romans called her Artemis Diana.

In the first century, Ovid, in the *Metamorphoses*, told the story of the terrible punishment inflicted on Actaeon by the goddess of the hunt, who was known to be merciless in her vengeance. Actaeon was an excellent hunter but his carelessness enraged her. One day Diana, tired from her hunt, had laid down her weapons, her quiver, spear and bow, removed her clothes and taken a refreshing bath in a spring together with her companions. Rambling through the woods, Actaeon chanced upon the bathers and cast an unintentional but fatal glance at the naked goddess. Seeing this as an assault on her virtue, Diana transformed the unfortunate hunter into a stag to ensure he would forever keep quiet about what he had seen. Actaeon wandered off into the woods, where his own hounds greedily tore him to pieces. Only then "was the anger of Diana, the quiver-bearing goddess, appeased," according to Ovid.[2] Artemis/Diana is usually depicted as a youthful huntress wearing a full- or knee-length robe and carrying a quiver, bow and arrow, or a spear (cat. 34). She is often accompanied by a dog or a hind (cat. 33). The marble statue of the so-called Dresden Artemis was modelled on an original from around 360–350 BCE attributed to the sculptor Praxiteles. It shows the goddess wearing a long, ungirded peplos, with her hair neatly tied up, and her body concealed down to her feet. Her right arm is raised to pull an arrow from the quiver; the left hand once held the bow. The graceful goddess of the hunt seems calm and composed, her unhurried gaze focused on some distant object. Is she aiming at a new target, a new prey?
SW

[1] *Homeric Hymns* 9, 6.
[2] Ovid, *Metamorphoses* 3.251–52.

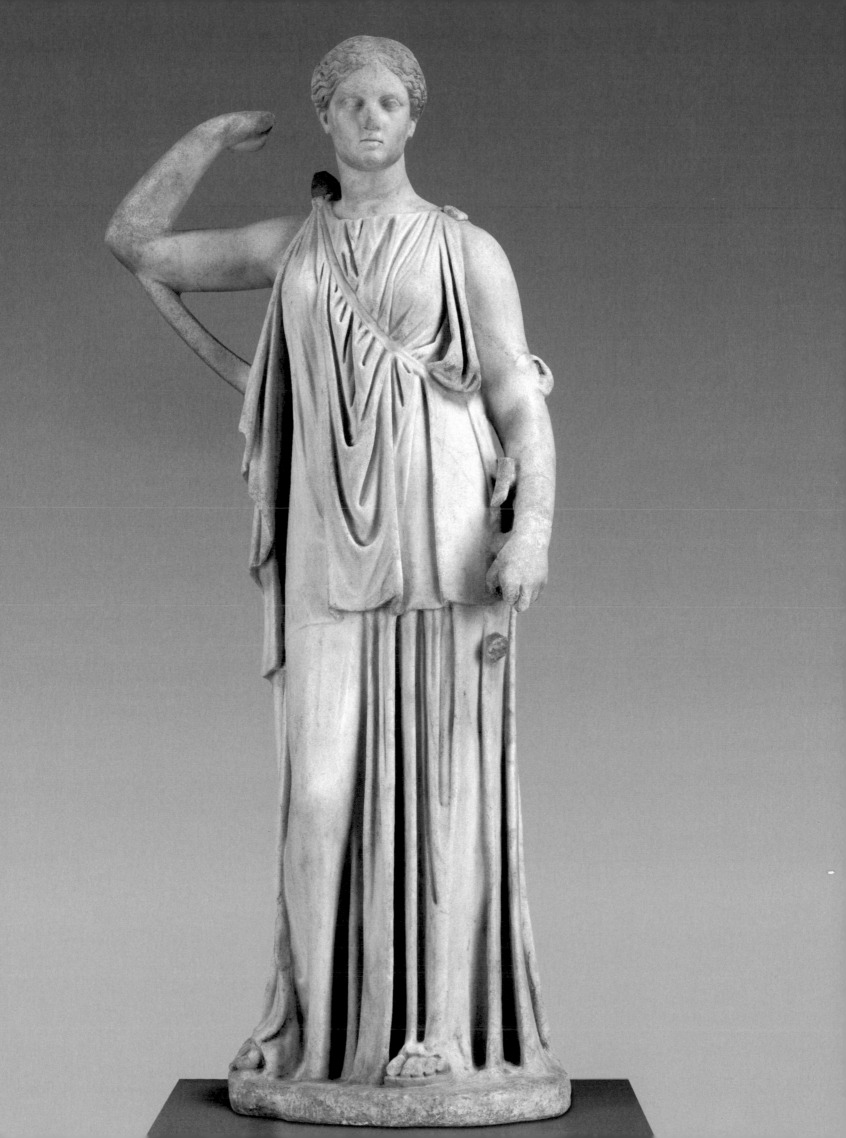

Poseidon, Blue-Haired Earth Shaker

7 Statue of Poseidon, Lateran Type
Second half of the first century CE, after an original from circa 300 BCE
White marble, height 106 cm
Acquired before 1733 in Rome
Inv. no. Hm 157
Lit.: Dresden Bildwerke II, cat. 97

Standing on the shore on a dark and stormy day in a howling gale, with the waves thundering up and churning the sea foam, it is not so hard to understand why the ancient Greeks associated these natural phenomena with an all-powerful divinity. Searching for the meaning of nature's fury, their imagination knew no bounds. According to the myth, the brothers Poseidon and Zeus drew lots to divide the cosmos; Poseidon won the seas as his domain. His palace lay deep down on the ocean floor, and with his team of horses he could charge through the raging waters as swiftly as the wind. He had enormous strength and displayed power and majesty in all his deeds.

Most representations of Poseidon closely resemble those of Zeus in appearance and manner, and this is also true of the Dresden statue. He has an athletic body, a thick beard, and unkempt locks which are often described as dark. His attributes are the trident, the dolphin, and various fish (cat. 35).

As ruler of the seas, Poseidon played a crucial role in a maritime country like Greece with its profusion of islands. He had to be continuously propitiated and humored. The *Homeric Hymns* praised him as "savior of ships" and implored him for help: "Farewell, Poseidon, blue-haired god who holds earth; with a kind heart, Blessed One, aid those who sail."[1]

One of his epithets was "earth shaker" (Ennosigaios) because as the god who churned up the sea he was also associated with earthquakes. He was also seen as the nurturer of plants (Phytalmios), for his power over water helped to make the earth fertile and promote growth—thus showing his gentle side. Like Athena, Poseidon was a deity of the horse—he was sometimes called "tamer of horses." When he pursued Demeter, the goddess of agriculture and fertility, she escaped his advances by transforming herself into a mare. But Poseidon finally managed to conquer her by assuming the form of a stallion. Notoriously ill-tempered, he frequently had disputes, including one with Athena over the possession of all the lands of Attica, in which Athena was eventually victorious. In the Trojan war he fought on the side of the Greeks, ruthlessly hunting down the Trojans. Returning home from that long war, Odysseus blinded Poseidon's son, the man-eating Cyclops Polyphemus, and Poseidon, furious at this, took his revenge by forcing him to roam the seas for ten years. Homer's *Odyssey* tells the story of Odysseus's wanderings.

With his wife Amphitrite, mistress of the oceans, Poseidon had a son called Triton (cat. 36), a hybrid being with a human torso and a fish tail. Together with many mermen and mermaids they lived in the sea, as can be seen in a monumental painting by Peter Paul Rubens from 1635 (Dresden, Galerie Alte Meister, Gal.-Nr. 964B). Poseidon's union with the earth goddess Gaia produced the giant Antaeus, who was invincible in wrestling until Heracles finally defeated him. He had many other children with nymphs and mortal women, who were mostly as wild and violent as he was.

The Dresden statue shows Poseidon in the pose of a ruler, his gaze directed into the distance and his leg resting on a dolphin. His thick hair still seems damp with seawater. Reminiscent of the larger-than-life size Poseidon, the Lateran Poseidon (Rome, Vatican Museums) is a copy of a Greek bronze which was probably by the sculptor Lysippos. The Dresden statue, of a reduced scale, served as a fountain figure, with water once bubbling out of the dolphin's mouth.
KK

[1] *Homeric Hymns* 22.5–6.

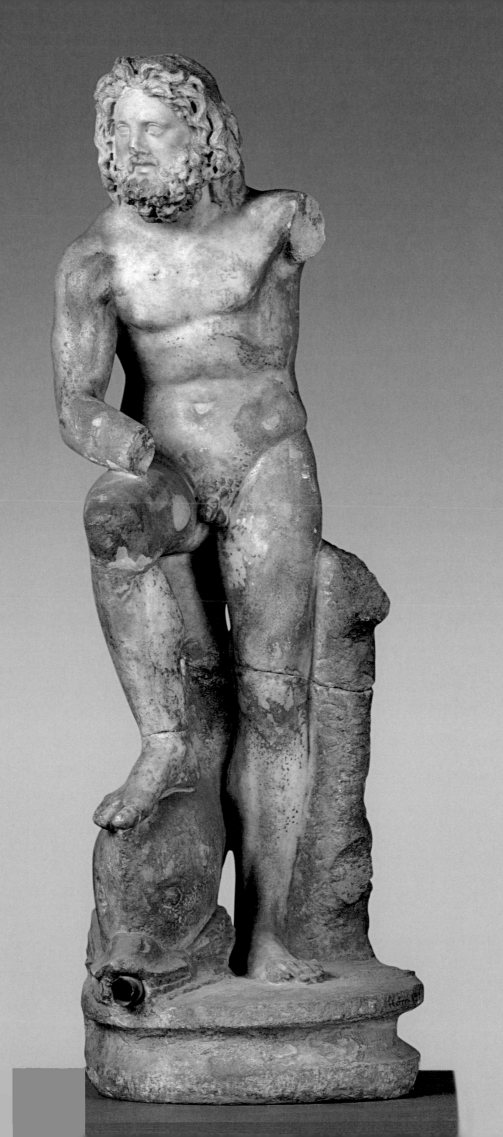

Aphrodite, Lover of Smiles

8 Statue of Aphrodite, Capitoline Type
Second half of the second century CE
Coarse-grained pale yellow marble, height 187 cm
Acquired in 1728 from the collection of Flavio Chigi, Rome
Inv. no. Hm 308
Lit.: Dresden Bildwerke II, cat. 33

If what one loves is beautiful, does it become ugly if that love turns into hate? For the ancient Greeks, the two categories of beauty and love were embodied by the goddess Aphrodite, who was called Venus by the Romans. Few other ancient divinities are still as familiar to us today as the goddess of love, fertility, and beauty. Her name is often used for beauty and wellness products; in the *Homeric Hymns* she is called "smile-loving Aphrodite."[1]

Aphrodite is sometimes said to be the daughter of Zeus and Dione, but according to the better-known myth of her birth she was created from the sea foam that gathered around Uranus's severed genitals after they had fallen into the sea; the Greek *aphros* means "foam." After emerging from the roaring waves completely naked (cat. 36), Aphrodite eventually reached the island of Cyprus. The chaste, radiant Aphrodite with a "finely crafted crown / of lovely gold"[2] on her head became a much-admired epitome of beauty: the woman of everyone's dreams. Surprisingly perhaps, she was married to Hephaestus, the ugly god of blacksmiths, to whom she was not always faithful. She was said to have had numerous affairs with mortals and gods, which produced a number of children, including Harmonia from her liaison with Ares; Hermaphroditus from her relationship with the messenger of the gods, Hermes; and Aeneas, the legendary founding father of Rome, who was the son of Anchises.

For better or for worse, most gods and humans, with very few exceptions, were under her spell. Even the great Zeus succumbed to her charms. It was Aphrodite who created the power of love and the wish to be loved, thus determining the actions of all those who were happily or unhappily in love, the lovers and the haters. She was supported by Eros, the god of love, by Anteros (requited love), Pothos (sexual longing), Himeros (uncontrollable desire), and finally Peitho (persuasion).

But even Aphrodite was not immune to heartbreak. After a boar had killed her beautiful lover Adonis, she was so grief-stricken that she made red flowers grow from his blood as a sign of her torment. Some traditions name these anemones, but other flowers, such as the pheasant's eye (*Adonis annua* in Latin), have also been associated with this myth. By bringing love into the world, the goddess also brought suffering and pain. The Trojan war was the result of a beauty contest in which Aphrodite emerged victorious over Hera and Athena. The bribe she paid to the adjudicator, Paris—the abduction of the beautiful but already married Helen—is also testimony to the sacrifices that Aphrodite's merits required.

From the seventh century BCE onwards, there have been representations of the goddess of love in all genres of art. Around 340 BCE, the Attic sculptor Praxiteles created a sculpture that showed her completely naked, the Aphrodite of Knidos. Since then artists have represented this most beautiful of all goddesses in many different shapes and poses, depicting the female nude as seductive, coquettish, vivacious, shy, or virtuous (cat. 37, 38). The Dresden statue also emphasizes Aphrodite's physical charms—even though, or perhaps precisely because, the naked goddess tries to cover her breast and pudendum and shyly averts her gaze.

Love, beauty, seduction, and desire, but also deception, rivalry, and revenge—everything was embodied in the figure of Aphrodite. Yet she was above all the goddess of sensual, sexual love and consequently of procreation—something which is indispensable to the continued existence of the human species.
SW

1 *Homeric Hymns* 5.16.
2 *Homeric Hymns* 6.7–8. and 6.19.

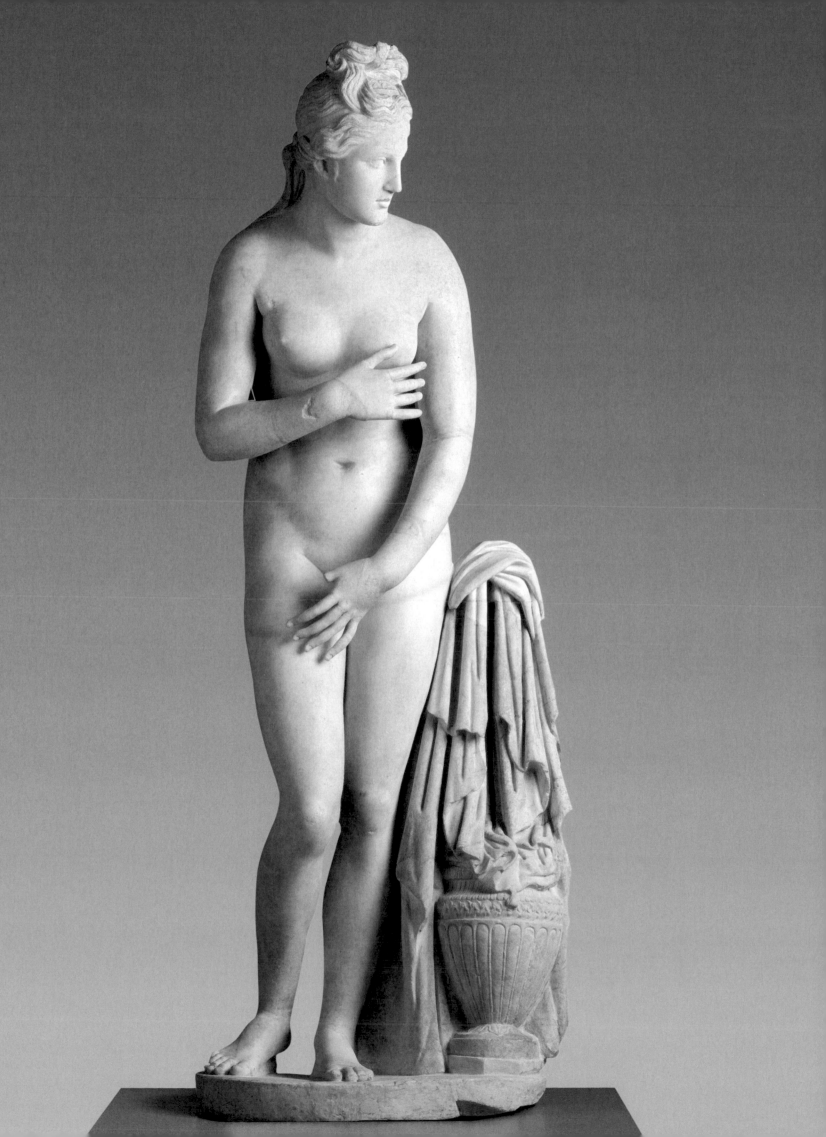

Demeter, the Nurturer and Nourisher

9 Statue of Demeter, Poggio Imperiale Type
Late fourth century CE, after an original from the mid-second century BCE
Marble, thought to be from Göktepe, Muğla, height 87 cm
Acquired in 1728 from the collection of Flavio Chigi, Rome
Inv. no. Hm 265
Lit.: Dresden Bildwerke II, cat. 138

Every summer, billowing fields of golden grain show that seeds have germinated, the soil is fertile, and there will be no lack of bread with which to feed people during the coming year. An ear of grain has symbolized fertility and wellbeing, but also the human hope for immortality since time immemorial. According to Homer, "fair-haired Demeter," the goddess of fertile soil and agriculture, was the one who "discriminates the chaff and the true grain" in ancient Greece.[1] Her daughter was Persephone, also called Kore ("the girl"). Demeter and Persephone/Kore were the two great goddesses of farming communities. A *Homeric Hymn*, written between the seventh and fifth century BCE, praises "Queen Demeter, who brings seasons, bears shining fruit,"[2] and tells an episode from the lives of mother and daughter that appeals to the reader's emotions with its vivid description of a mother's suffering. Hades, the god of the underworld, had abducted Persephone/Kore, similar in every way to her beautiful mother, when she was gathering flowers. As Demeter desperately searched for her child, she was so distraught that she let the earth become barren, refused to eat and tore up her clothes. When Persephone/Kore was finally found, the gods held long negotiations about her return, but it was revealed that the young woman, having eaten a few pomegranate seeds in the underworld before leaving, was bound to it forever. As a compromise it was decided that she should

remain with Hades for six months of the year and with her mother for the other six. When she stayed with Hades it was winter, and spring awakened when she returned to her mother. Persephone thus came to embody the eternal cycle of growth and decay.

Demeter, who during her search for her daughter had experienced the life of humans on earth, asked the youth Triptolemus to give them grain and teach them agriculture. The Eleusinian votive relief in the National Archaeological Museum of Athens (440–430 BCE) depicts Triptolemus flanked by Demeter and Persephone. Demeter helped people to grow and process cereals and also assisted farmers with threshing grain on the barn floor.

The cult of the great earth goddess, as she was sometimes also called, was popular throughout ancient Greece. Demeter had sanctuaries everywhere, and the most renowned of these was in Eleusis, where every year the so-called Eleusinian Mysteries took place in her honor, reminding people of Persephone's reunion with her mother. The ear of grain as a symbol of fertility played an important role in the ceremonies. Demeter's beneficial influence was felt not just in the countryside but also in the Greek city-states. She established marriage and brought law and order to public life, thus acquiring the title of Demeter Thesmophoros, the law-giver. She had two sons with the mortal youth Iasion, Plutus (wealth) and Philomelus (lover of song); and a daughter with Poseidon, Despoina ("the mistress"), who was venerated in Arcadia and had numerous shrines there.

The Romans called her Ceres, while in Egypt she merged with Isis and in Phrygia with Kybele. Pictorial representations show Demeter as dignified matron, wearing a chiton and mantle; one such example is the seated statue from the Demeter shrine in Knidos (London, British Museum).
The Dresden statue can be identified as Demeter by the wreath of braided ears of corn; the poppies she is holding in her left hand mark her relation to the underworld. It was probably placed inside a Roman villa together with three other statues of divinities, which are also kept in the Dresden antiquities collection. Stylistic characteristics suggest a dating to late antiquity, the middle years of the fourth century, when Christianity was already becoming a leading religion. Old heathen forms of faith continued to exist in parallel to early Christian ones but no longer had any cultic significance.
KK

[1] Homer, *Iliad* 5.500.
[2] *Homeric Hymns* 2.54 ff.

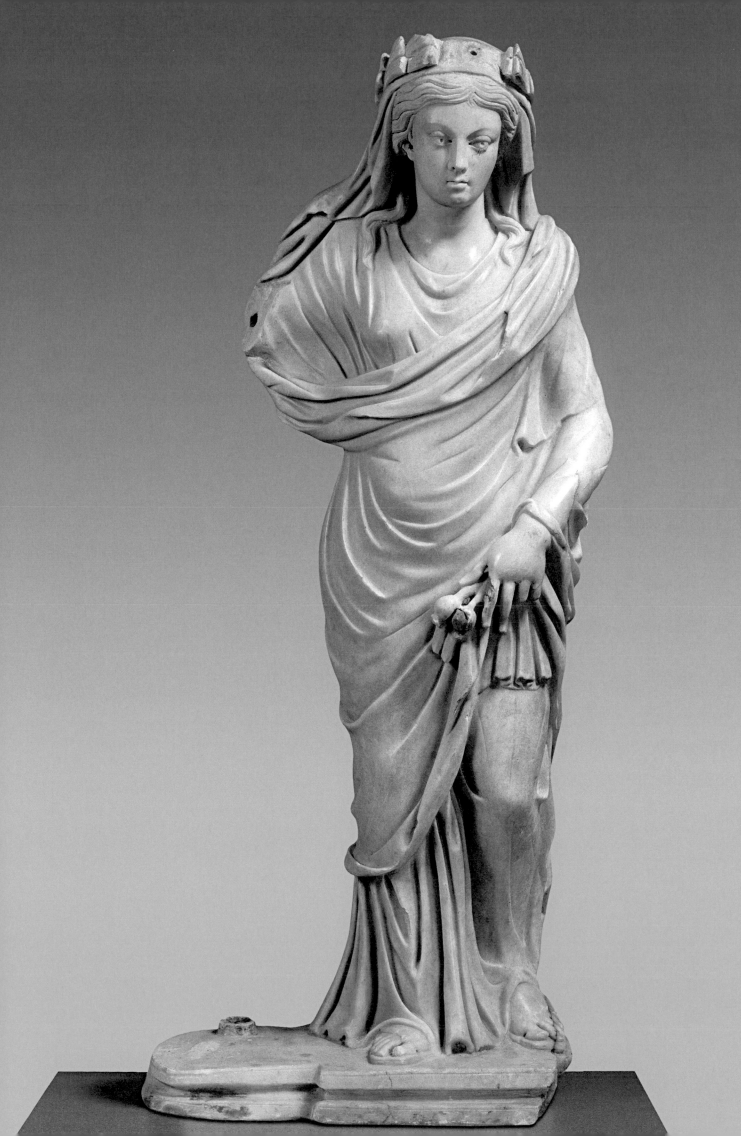

Hestia, Goddess of Hearth and Home

10 *Hermes and Hestia*
Partial cast of the Puteal of the Twelve Gods (Albani Puteal), Rome, Capitoline Museums
Before 1857, after an original from the first half of the second century CE
Plaster, height 50.5 cm
Acquired before 1857
Inv. no. ASN 3025
Lit.: Hettner 1857, no. 27

When we invite friends to a dinner party, we obviously make sure they get a warm welcome; we give them plenty to eat and drink and, above all, offer them the best of everything we can provide. The kitchen, and the stove in particular, are the center of activity. Today we might have luxury kitchen islands in the middle of our kitchens, but in antiquity the fire in the hearth was at the center of the house or temple. The charcoal was kept glowing by a covering of white ash, and the embers were never left to die. Hestia, the goddess of domestic life, kept watch over all this. The largest and tastiest pieces of meat were sacrificed to her, for "Mortals have no / feasts without you," according to a *Homeric Hymn* dedicated to "revered and dear Hestia."[1]

Another *Homeric Hymn* recounts that Poseidon and Apollo both wanted to wed Hestia, but "she was unwilling / and hard, refusing their offers of marriage."[2] She swore by Zeus that she would never marry and would always remain a virgin. As a substitute for marriage, Zeus gave her dominion over the hearth, the household, and the home, and from then on, she was enthroned in the center of every house and temple. The *Homeric Hymn* tells us: "All people revere her in every temple, / Hestia, the most august of the gods."[3]

Since Hestia's realm was the house it is not surprising that she was a serious, quiet goddess, who cannot be identified by any particular attributes. There are no anecdotes about her. But wherever a fire glowed or blazed in the hearth, she was present.

She was on friendly terms with Hermes, perhaps because they both had close and direct relationships with mortals and their private spheres—Hestia as guardian of the fire, Hermes as protector and frequent benefactor of humans. They embodied the domestic and the private, and wherever a house was built or a roof erected over a hut, Hestia and Hermes kept a watchful eye over it (cat. 14). The *Homeric Hymns* praise Hermes, "whose golden wand grants good fortune," and tell us that the two "stay in these lovely homes together in friendship."[4]

In ancient Rome Hestia was equated with Vesta. The ruins of the circular Temple of Vesta still stand on the Roman Forum, and it was there that Vesta's priestesses, the Vestas, who were sworn to celibacy, guarded the sacred fire that was never allowed to go out. It is said that Aeneas originally brought the Vesta cult to Rome from Troy. According to tradition, the legendary second king of Rome, Numa Pompilius, built a temple for Vesta on the Palatine Hill, and a state cult dedicated to her quickly developed there. For the festival of Vesta, women brought bread and cakes to the temple as votive offerings.

Hestia/Vesta is represented as a stately matron in rich robes, with a veil modestly covering her head and shoulders (cat. 39). She often appears together with Hermes, as she does on this wellhead, the Puteal of the Twelve Gods (Rome, Capitoline Museums).
KK

[1] *Homeric Hymns* 29.4.10–11.
[2] *Homeric Hymns* 5.25–26.
[3] *Homeric Hymns* 5.32–33.
[4] *Homeric Hymns* 29.8–9.

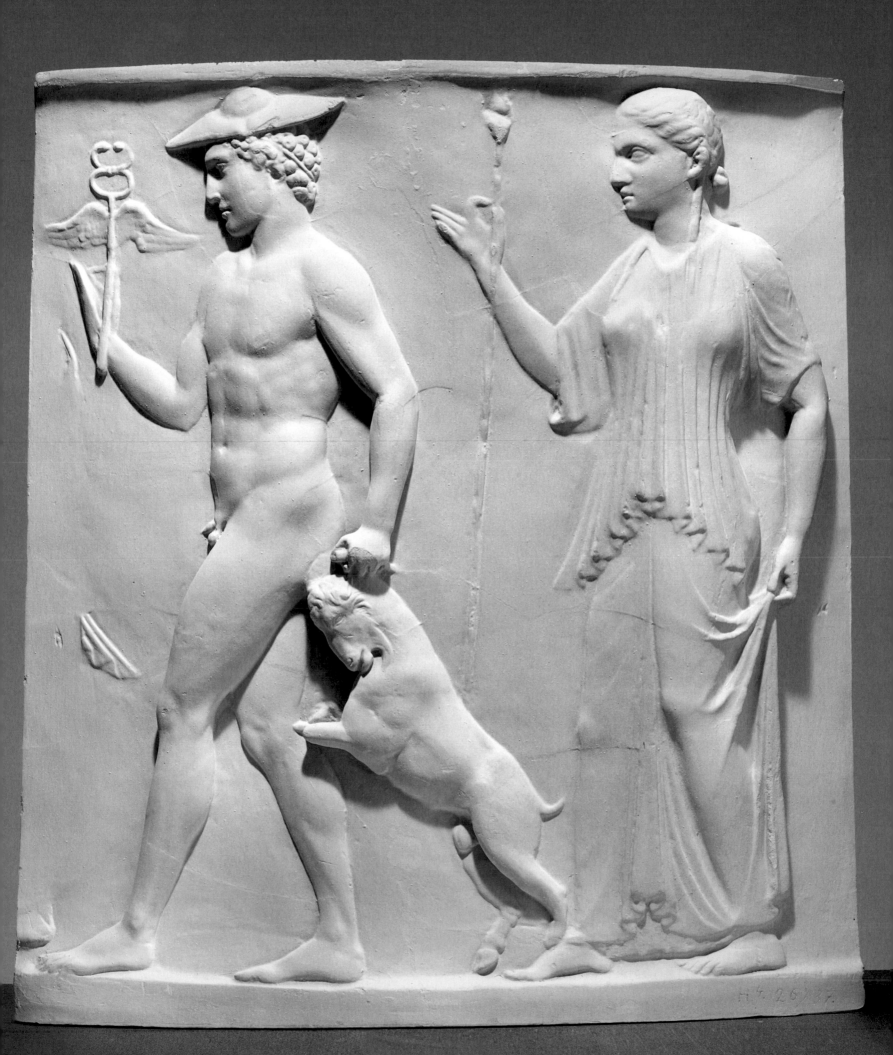

Hephaestus, the Crook-Footed God

11 *Head of Hephaestus/Vulcan From a Relief Tondo*
Late fourth century CE
Fine-grained white marble, height 29 cm
Gifted by Paul Arndt in 1893
Inv. no. 263
Lit.: Dresden Bildwerke IV, cat. 24

An abandoned child, a sweaty laborer, a cuckold, a recluse and a misfit—Hephaestus seemed anything but god-like. The god of fire, blacksmiths and craftsmen was Hera's son. According to one version of the myth, Hera conceived him alone, without any act of procreation; in another account he was fathered by Zeus. Unfortunately, baby Hephaestus was born into this world—or rather onto Mount Olympus—with crippled legs. He suffered from lameness throughout his life as a result, bearing the mocking name "the crook-foot"; Hesiod introduces him as the "the famous Lame one."[1] Disgusted by his disability, his hard-hearted mother hurled him in a high arc off the top of Olympus. After spending an entire day flying through the air, the boy landed in the sea or on the island of Lemnos, where during the next nine years he was brought up by the nereid Thetis and the oceanid Eurynome.

The opportunity to avenge himself on his mother arose when Hephaestus, now an adult, discovered his talent for smithery. He fashioned an ornate golden throne with invisible shackles and presented it to Hera as a gift. As soon as the goddess sat down upon it, the chains entrapped her and held her fast. The Olympians all strove to free Hera, but in vain; none of them could loosen her bonds. Hephaestus remained obdurate, and in the end only relented after Dionysus, the god of wine, had tricked him into a bout of drinking and Dionysian intoxication. In this drunken state, Hephaestus was brought back to Olympus and freed his mother from the wrought-iron shackles.

In an attempt to reconcile the divine family, both Dionysus and Hephaestus were welcomed to Olympus, and the rather unattractive blacksmith god was given Aphrodite, the beautiful goddess of love, as his bride. Aphrodite betrayed him for his brother Ares, the god of war, to whom Hephaestus was linked not just by their joint parentage, but also by business interests—after all, weapons and war go hand in hand. Using his technical skills again, Hephaestus took his revenge on the illicit lovers by entangling them in a finely woven web. He then exposed them *in flagrante* to public ridicule. It was an amusing trick, but he still remained a scorned and resentful cuckold.

Unlike his divine siblings and relatives, Hephaestus was neither easygoing nor cheerful. Conducting a sweaty, dirty trade, he produced famous works of art such as the shield of Achilles, which depicted the world and all its aspects. He also made his wife's magic girdle, and, together with Athena, created the first woman, Pandora. But his pleasing works and divine skill remained over-shadowed by his physical infirmity.

For a long time, most representations of this god focused on his return to Olympus (cat. 40). The inebriated god rides on an equally inebriated mule, accompanied by a no less tipsy Dionysian retinue, as if to demonstrate the consequences of reaching for the cup too frequently. Hephaestus is usually depicted as bearded, in a short tunic and a *pilos*, the typical cone-shaped cap worn by workers. This head of Hephaestus, from a round marble relief from the fourth century CE, illustrates the long pictorial tradition of the divine blacksmith, whom the Romans called Vulcan.
SW

[1] Hesiod, *Theogony* 945. Quoted here from Hugh Gerard Evelyn White, *Hesiod, the Homeric Hymns, and Homerica* (1914).

Ares, the Sacker of Cities

12 *Bust of Ares, Ares Borghese Type*
130–150 CE, after an original from the late fifth century BCE
Fine-grained brilliant white marble, height 82 cm
Acquired between 1723 and 1726 from the Brandenburg collection of Frederick William I
Inv. no. Hm 91
Lit.: Dresden Bildwerke II, cat. 113

Since antiquity, warfare has changed to such a great extent—through the deployment of neurotoxins, drones, and robots, for example—that the gory, hand-to-hand battles of Ares, which involved a direct physical attack on the adversary, have long been obsolete. In antiquity, Ares, the legitimate son of Zeus and Hera, was the insatiable god of war and all its horrors. He seemed to relish bloodbaths and senseless carnage; Hesiod called him the "sacker of cities."[1] Ares had inherited an unyielding and violent temper from his mother, and for this everybody detested him, even his father Zeus. A merciless warmonger, he raged, destroyed, and ran riot—a very different kind of warrior from his half-sister Athena, who was an accomplished tactician and strategist. The rivalry of the two half-siblings came to the fore when the invincible Athena took the side of the victorious Greeks, while Ares, the corruptor of men, fought on the losing Trojan side.

Ever since the days of Homer, Ares has been associated with all the horrors and brutalities of war. This and the fact that he never tired of going into battle did not help him to gain popularity. Although he is often equated with Mars, the Roman god of war (cat. 41), the two are very different—Mars had none of Ares's bloodthirsty nature and was greatly respected and venerated by the Romans.

Ancient literature contains many stories about Ares's aggressive, odious, and malevolent character, but one of the most popular tales about him, first told by Homer in the *Odyssey*, concerns an amorous adventure. Aphrodite, the beautiful goddess of love, was married to the crook-footed Hephaestus, god of blacksmiths, but she was not always faithful to him. One of her lovers was Hephaestus's brother, who was certainly better looking than her husband. When the cuckolded Hephaestus learned of the affair from Helios, he came up with a ruse to expose the two adulterers. He constructed a gossamer-thin but very strong net and laid it out over the marriage bed in which the couple were enjoying themselves during his absence. When the lovers lay down, the net snapped shut like a snare and imprisoned them. Caught *in flagrante*, Ares and Aphrodite were displayed to the assembled gods, who roared with laughter.

In visual art, Ares is usually depicted as a strong and heroic young man rather than a blood-soaked tyrant. The bust in the Dresden collection shows the warrior in a calm, focused pose. Across his broad, bare chest hangs a sword strap decorated with reliefs; his helmeted head is slightly inclined, and the expression on his beardless face, which is framed by long hair, seems thoughtful. The Romans appear to have found peaceful statues of this type suitable for display together with the goddess of love. The Dresden bust also originally belonged to such a group of statues, which were remodeled in the post-antique period, as can be seen from the remains of Aphrodite's thumb in Ares's neck.

The Roman statue groups with the original immortal parents—Mars as father of Romulus and Venus as mother of Aeneas—symbolize harmony and concord as a central theme of private and state plastic art in Rome. This is why the godlike statues were often complemented by portrait heads of married couples to demonstrate *concordia*. In Greek myth, the goddess who incarnated this quality was called Harmonia; she was the daughter of Ares and Aphrodite.
SW

[1] *Hesiod, Theogony* 936.

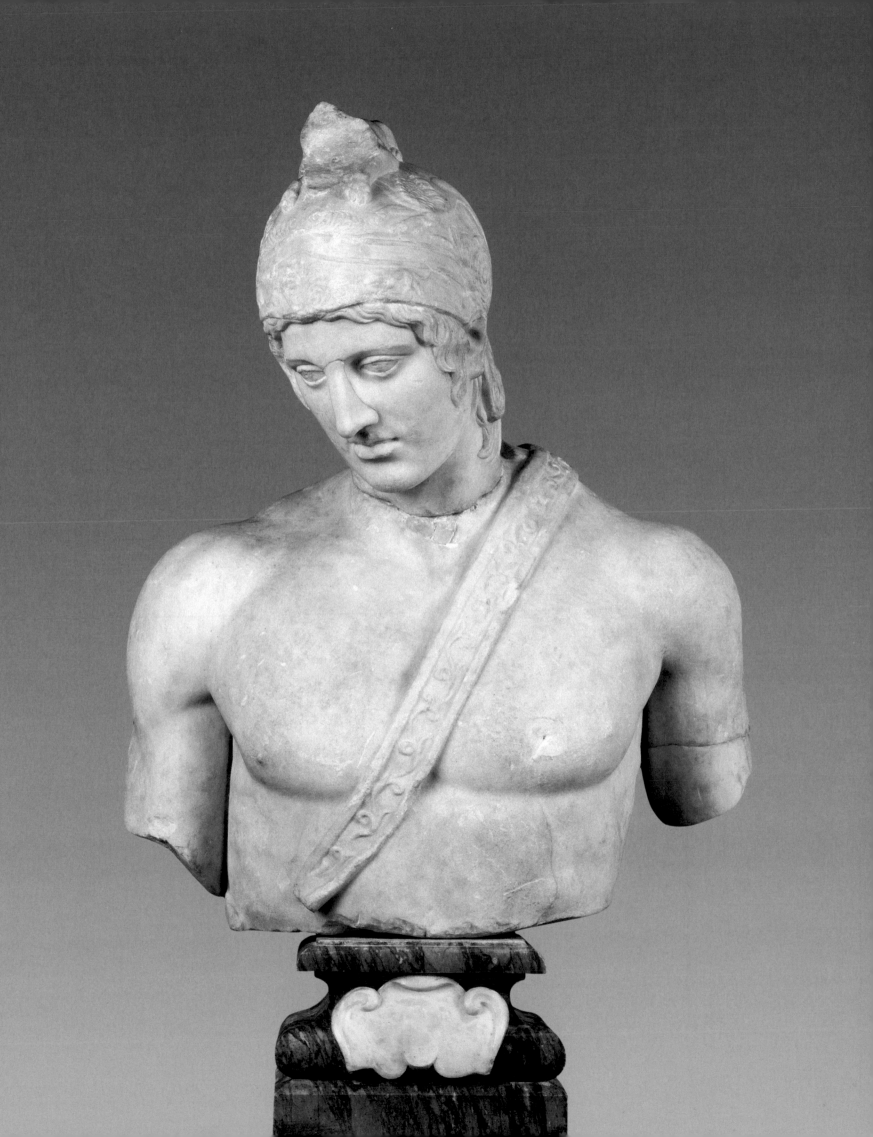

Dionysus, Bringer of Joy, Deliverer From Care

13 *Dionysus with Nebris and Panther*
Between the second half of the second century and the early third century CE
Yellowish macrocrystalline marble, height 165 cm
Acquired in 1728 from the collection of Alessandro Albani, Rome
Inv. no. Hm 292
Lit.: Dresden Bildwerke II, cat. 133

Festivals are important moments in the year—today as in the past. In ancient Greece, festivals in honor of the gods were high points in the calendar. The Eleusinian Mysteries were held in honor of Demeter in the city of Eleusis, Athena's Greater Panathenaea took place in Athens, and the Olympic Games, dedicated to Zeus, were played in and around the sacred grove of Olympia. But the god who could boast of having the most exuberant festivities in ancient Greece was Dionysus. The Romans called him Bacchus, and his Roman festivals, the Bacchanalia, were just as renowned and notorious. Dionysus/Bacchus was the god of wine, intoxication, ecstasy, and fertility. In merry processions and drunken revelry, people indulged in the god's gift—wine and all that went with it. Transported by the joyous frenzy and ecstatic effects of drinking, the participants felt at one with the god, filled up and enthused by him. Dithyrambs, festive choral hymns sung in honor of Dionysus, are thought to be the origin of Greek theater. The works of the great dramatists Aeschylus, Sophocles, and Euripides originated in this tradition.

The birth of Dionysus was as miraculous as those of Athena and Hermes. He was the son of Zeus and a mortal woman, Semele. When the latter, a princess from Thebes, became pregnant, Hera coaxed her into asking Zeus to reveal his true likeness to her. But when Zeus complied and appeared in his divine form, accompanied by thunder and lightning, Semele could not bear such an awesome sight and died of shock. To save the unborn child, Zeus sewed it into his thigh and carried it there until its birth. Worried that the jealous Hera might harm the infant, he asked the half-brother of the boy, Hermes, to take Dionysus to the nymphs on Mount Nysa, where they and the wise old satyr Papposilenus brought him up. An immigrant among Greek gods, probably from Thrace or Phrygia, Dionysus entered Greek culture relatively late, but he became one of the most important of the Olympian deities. As a bringer of joy (Charidotes) and a deliverer from care and worry (Lysios) he gave humans the grape, which, along with the cantharus and the thyrsus, a rod encircled with ivy, was one of his attributes (cat. 42). As son of a god and a mortal he encompassed life and death, nature and culture, body and soul, love and violence. His innumerable epithets are testimony to his many different functions, which encompass the whole spectrum of the living world.

Dionysus appeared both as awe-inspiring god—bearded and clad in long robes, as in the statue of the so-called Sardanapalus type (Rome, Vatican Museums)—and as a smooth-bodied youth enjoying an easy life, "draped with ivy and laurel," according to the *Homeric Hymns*.[1] He is thus the incarnation of the beautiful young man at peace with himself (cat. 43), the bringer of grapes who became a benefactor to mortals. But he also took cruel revenge on all who defied his cult of worship. Euripides tells the disturbing story of this vengeance in his last great tragedy, *The Bacchae*, which won first prize in a theater contest.

One of the most famous love stories of antiquity is that of Dionysus and the Cretan princess Ariadne. Ariadne had fallen in love with Theseus after helping him to slay the Minotaur, but he subsequently abandoned her on the island of Naxos while she slept. Dionysus appeared as her savior and traveled across the world with her in triumph. In antiquity, the relationship between Dionysus and Ariadne also held religious significance. The union of a mortal with the god Dionysus promised immortality after death and a good life in the next world.

This statue, which can be identified as Dionysus by its attributes, shows the wine god with a panther at his side. His hair is adorned with an ivy wreath with berries and grapes. His raised left hand originally grasped a thyrsus, and his right hand held a vessel. His torso is covered by very fine deerskin. The statue represents the wine-giving Dionysus, an image popular in the Roman imperial period.
KK

[1] *Homeric Hymns* 26.9.

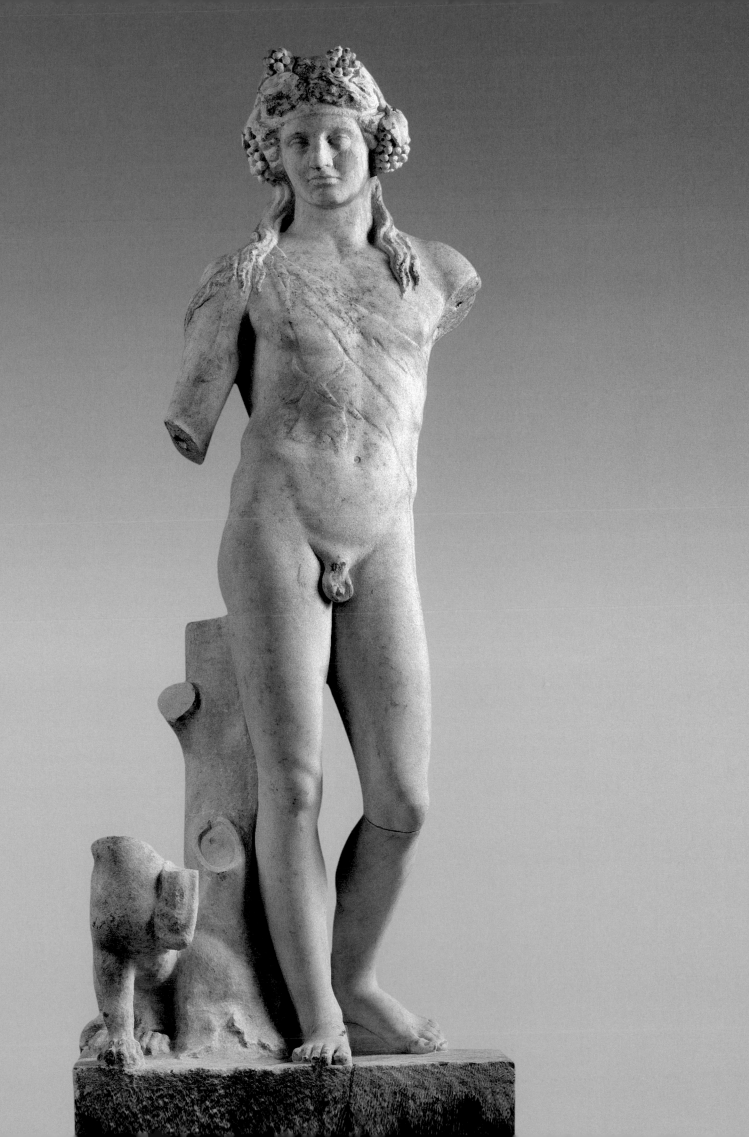

Hermes, Guide and Giver of Good Fortune

14 *Hermes, Farnese Type*
Roman imperial period, after an original from the fourth century BCE
Pale yellow marble, height 215 cm
Acquired in 1728 from the collection of Alessandro Albani, Rome
Inv. no. Hm 114
Lit.: Dresden Bildwerke II, cat. 115

Probably no other god in the whole of ancient literature has been the central character of such delightfully funny tales as Hermes, named Mercury by the Romans. The account of the unusual first days of this mischievous deity is particularly hilarious. Like Dionysus and Athena, he had a miraculous birth. The child of Zeus and the nymph Maia, he was born in a cave on Mount Kyllene in Arcadia. On the very same day he demonstrated his ingenuity by unwinding his swaddling clothes and sneaking off in search of adventure. When he encountered the herd of cattle belonging to his half-brother Apollo he craftily stole it, and then firmly denied the deed when questioned by Zeus, as told in the *Homeric Hymns*: "I'm honest and don't even know how to lie. [...] / Glancing aside, the Slayer of Argos spoke, / clinging to the swaddling clothes on his arm. / Zeus laughed aloud to see his deceitful child / so skillfully deny the business of the cattle."[1] Zeus made the inventive infant the messenger of the gods and gave him the golden herald's staff, winged shoes, and broad-brimmed traveler's hat which became his attributes.

Hermes had many duties to perform on Olympus and on earth. Too many, perhaps. In Lucian's *Dialogues of the Gods* the young god grumbles endearingly about his excessive burdens, listing them in a cheerful tirade: "Is there a god in Heaven, mother, more miserable than I am?"[2] He complains that his days are full of chores: he has to wait on everybody, sweep the dining-room and shake out the cushions, take orders from Zeus, and rush back and forth between heaven and earth conveying messages. Even at night there is no chance of rest, he says, because that is when he has to accompany the souls of the dead into the underworld and negotiate with Hades. What is more, he is sent to Argos and Boeotia simply to entertain Zeus's lovers, Danae and Antiope. To top it off, he adds, he has to wait on Dionysus and Heracles, despite the fact that these two are merely the sons of mortal women. But Hermes was a genial god, who was friendly towards mortals and had all kinds of relationships with them. The *Homeric Hymns* pay homage to him as a "guide who gives joy and good fortune."[3] He was the patron of music, and his ingenious inventions included not only the musical scale but also the lyre, which he played beautifully and gave as a gift to Apollo. He was present in oratory schools and supported the art of public speaking. Travelers and merchants worshipped him as their protector, who maintained the streets and the public right of way. Wherever people measured and weighed things, Hermes was involved. Scales, weights, and measures were his invention. He would be there when negotiations were conducted or deals were struck.

He consoled the families of the deceased at the graveside and lovingly cared for the souls of the dead, accompanying them into the realm of Hades. Hermes as a guide of souls can be seen on a Roman copy of a Greek relief from the fifth century BCE, which shows him at the moment when he is about to take Eurydice back into the underworld (Naples, Museo Archeologico Nazionale). In a poem about this relief Rainer Maria Rilke describes Hermes thus: "The god of speed and distant messages, / a traveler's hood above his shining eyes, / his slender staff held out in front of him, / and little wings fluttering at his ankles; / and on his left arm, barely touching it: she."[4]

Hermes had numerous lovers, mostly nymphs; sometimes he tried to catch a mortal girl too, using the entrancing power of his "golden wand" (cat. 44). But he also loved the most beautiful of the goddesses, Aphrodite, and had a son, Hermaphroditus, with her.

As the god of country roads, Hermes was venerated with stone columns at crossroads. These developed into what became known as herms—rectangular pillars tapering downwards and crowned with a human head. The phallus protruding from their front is a sign that Hermes was also venerated as a god of fertility. Herms placed in gymnasia and public places, showing Hermes with an awe-inspiring, stately head, paid homage to the god of young men, orators, and philosophers (cat. 45).

Hermes/Mercury was usually represented as the ideal of young male beauty. The Dresden statue emphasizes his elegance and grace: The messenger of the gods and guide of souls, in the bloom of youth, stands lost in thought. It was not until the nineteenth century that this statue was identified as Hermes. The model for this Roman copy was a Greek work from the fourth century BCE from the circle of Praxiteles.

KK

[1] *Homeric Hymns* 4.369–90.
[2] Lucian, *Dialogues of the Gods* 4.24. Quoted here from "Dialogues of the Gods: Hermes and Maia," in *Soloecista. Lucius or The Ass. Amores. Halcyon. Demosthenes. Podagra. Ocypus. Cyniscus. Philopatris. Charidemus. Nero*, trans. M. D. MacLeod (Cambridge, MA: Harvard University Press, 1967).
[3] *Homeric Hymns* 18.12.
[4] "Orpheus. Eurydice. Hermes," in *The Selected Poetry of Rainer Maria Rilke*, ed. and trans. Stephen Mitchell (New York: Vintage International, 1989), 51.

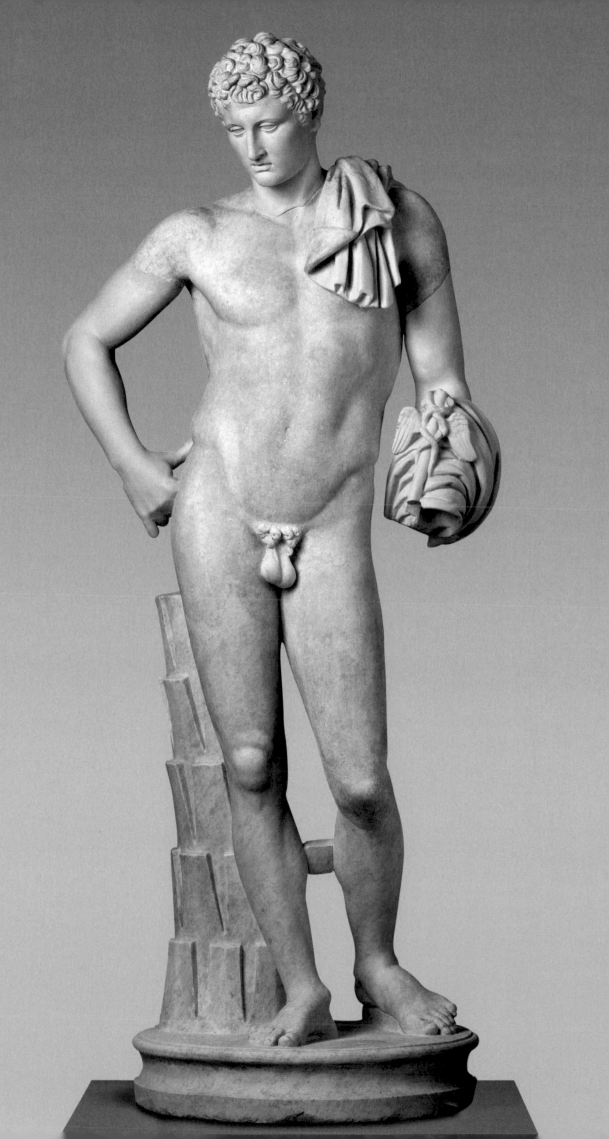

15 Head of a Muse, Thalia Type
130–140 CE
Fine-grained yellowish marble,
height 27.7 cm
Found on the western slope of
Monte Calvo (Villa of the Bruttii
Praesentes family) in 1826; acquired
in 1892 via Paul Arndt from the
Borghese collection, Rome
Inv. no. Hm 189
Lit.: Dresden Bildwerke II, cat. 60

**16 Head of a Muse With
Pine Wreath, Euterpe Type**
120–140 CE
Fine-grained white marble,
height 34.5 cm
Acquired in 1728 from the collection
of Flavio Chigi, Rome
Inv. no. Hm 135
Lit.: Dresden Bildwerke II, cat. 61

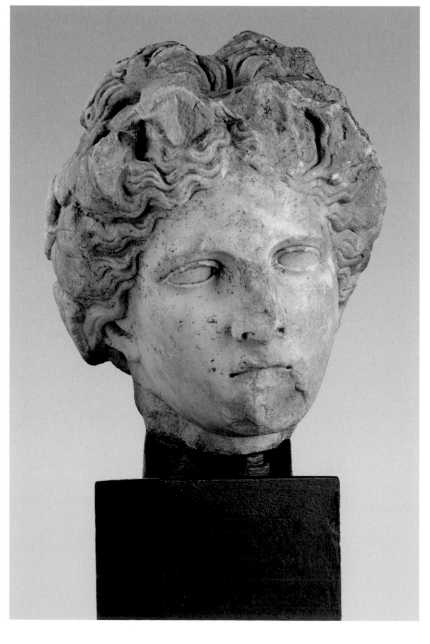

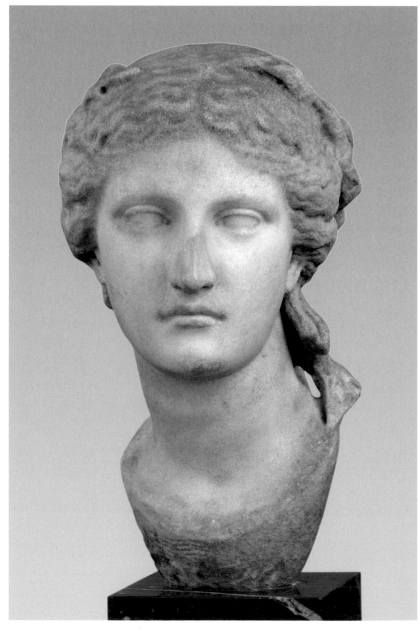

**17 Terracotta Statuette of Erato
With Kithara**

Early second – early first century BCE
Terracotta, height 25.8 cm
From Myrina; acquired in 1889 from
Alfred O. van Lennep in Smyrna
Inv. no. ZV 764
Lit.: Faeda 1994, no. 182, ill. 717

**18 Terracotta Statuette of Erato
With Kithara**

Late first century BCE – early first
century CE
Terracotta, height 24.5 cm
From Myrina; acquired in 1889 from
Alfred O. van Lennep in Smyrna
Inv. no. ZV 763
Lit.: Faeda 1994, no. 206, ill. 718

19 Terracotta Statuette of a Dancer

Late second – early first century BCE
Terracotta, height 26 cm
From Myrina; acquired in 1887 in Smyrna
Inv. no. ZV 742
Lit.: Knoll et. al. 1993, no. 63

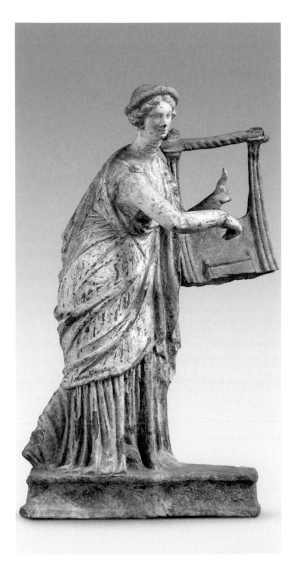

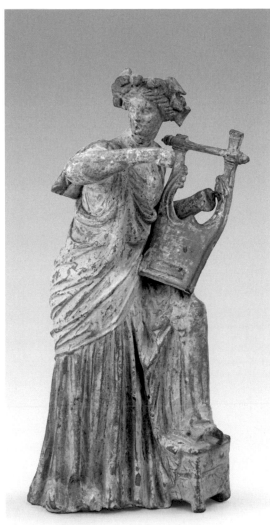

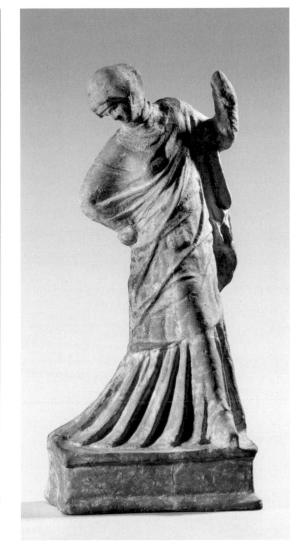

**20 Head of a Contemplative Muse,
Polyhymnia Type**

Second half of the first century CE,
after an original from circa 160 BCE
White, translucent marble,
height 21 cm
Acquired in 1728 from the collection
of Flavio Chigi, Rome
Inv. no. Hm 173
Lit.: Dresden Bildwerke II, cat. 58

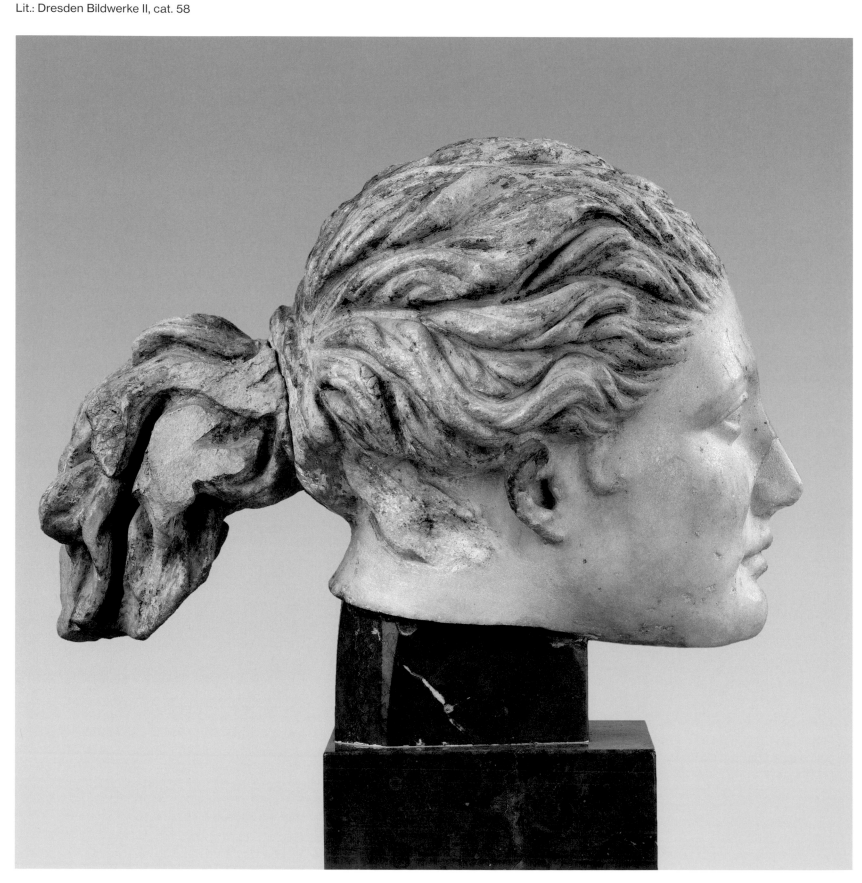

21 *Head of a Muse*
Last third of the first century BCE –
early first century CE
White, translucent marble, height 21 cm
Acquired in 1728 from the collection
of Flavio Chigi, Rome
Inv. no. Hm 123
Lit.: Dresden Bildwerke II, cat. 62

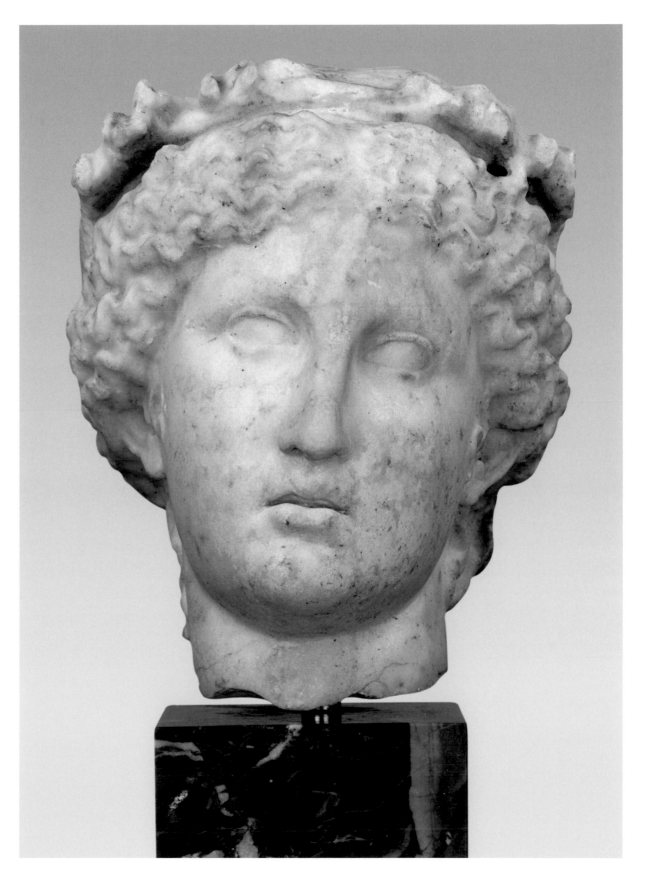

22 Pelike: Europa on the Bull

Attic red-figure, circa 430 BCE,
Phiale Painter
Terracotta, height 24.8 cm
Found in Nola; acquired in 1873 via the
aus'm Weerth collection from the Sayn-
Wittgenstein collection
Inv. no. Dr. 322
Lit.: CVA, 44–45, ill. 31

23 Head of a Bearded God: Zeus?
Second half of the first century CE
Medium-grained white marble, height 32.5 cm
Acquired between 1723 and 1728 from
a private collection in Rome
Inv. no. Hm 164
Lit.: Dresden Bildwerke II, cat. 110

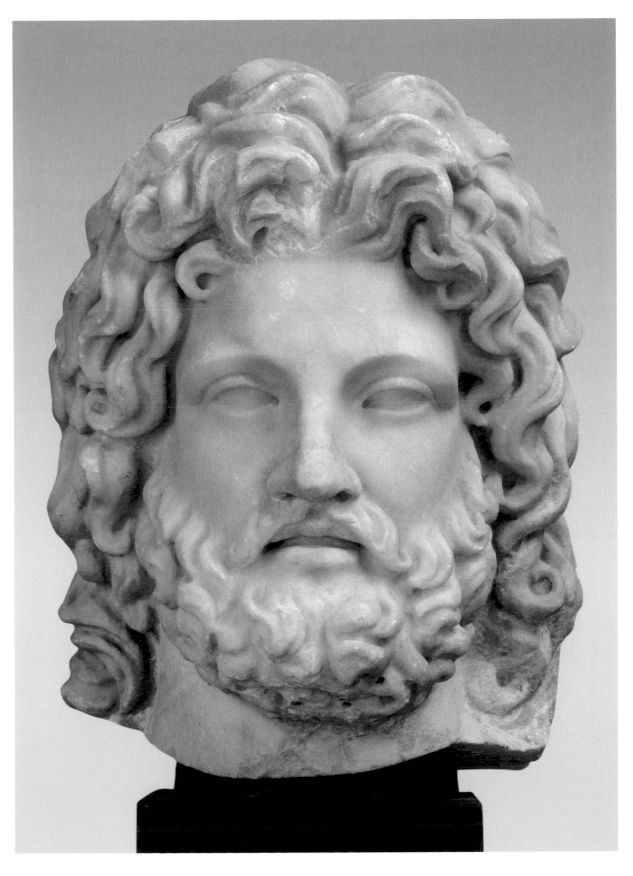

24 Terracotta Statuette of an Enthroned Goddess
Mid-fifth century BCE
Terracotta, height 24 cm
From Paestum? Acquired in 1886 from
Hugo Klein
Inv. no. ZV 467
Lit.: Winter 1903, no. 1, 2

25 *Terracotta Statuette of an Enthroned Goddess*
Circa 500 BCE
Terracotta, height 20.8 cm
From Athens? Acquired in the 1840s
from the collection of Otto Magnus von
Stackelberg
Inv. no. H4 41/343
Lit.: Winter 1903, no. 2c as addendum
to no. 2

26 Lekythos: Helmeted Head of Athena
Attic black-figure, circa 480–470 BCE,
Athena Painter
Terracotta, height 22.5 cm
Acquired in 1897 from E. P. Triantaphyllos,
Athens
Inv. no. ZV 1700
Lit.: Dresden 2000, no. 51

27 Panathenaic (Pseudo-)Prize Amphora:
Athena Ready for Battle, and Athletes
with Discuses and Halteres
Attic black-figure, circa 500 BCE
Terracotta, height 28 cm
Acquired in 1892 in Constantinople
Inv. no. ZV 1106
Lit.: Dresden 2000, no. 50

28 Head of Athena,
Type of Myron's Athena
First half of the first century CE,
after an original from circa 450 BCE
White marble, height 33.5 cm
Acquired in 1899
Inv. no. Hm 48
Lit.: Dresden Bildwerke II, cat. 1

29 Torso of Running Goddess,
Probably Athena
120–140 CE
Antique torso made from onyx marble
(alabastro onice) and lumachella
rosso scura; upper part and base
with feet are baroque additions,
height (with base) 144 cm
Acquired in 1728 from the collection
of Flavio Chigi, Rome
Inv. no. Hm 251
Lit.: Dresden Bildwerke II, cat. 54

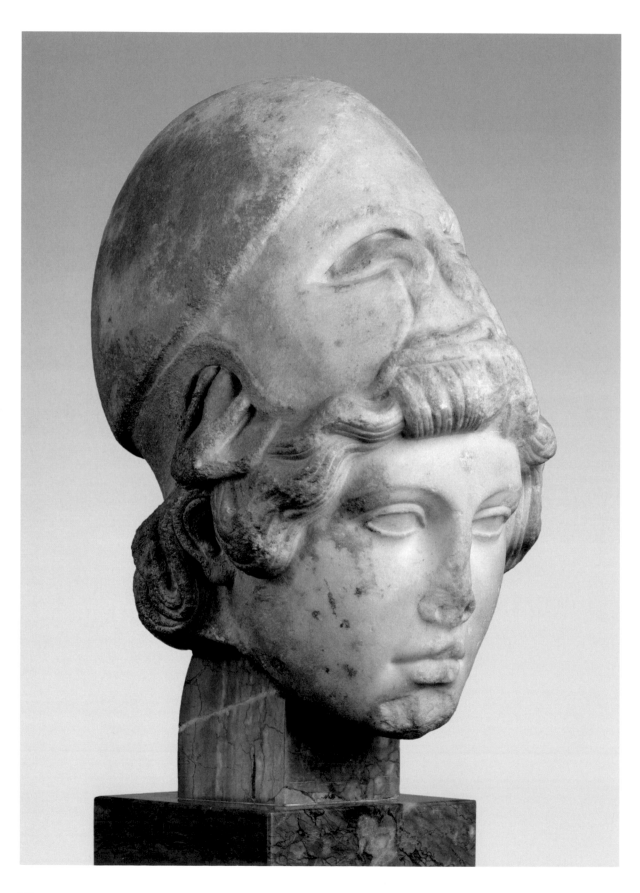

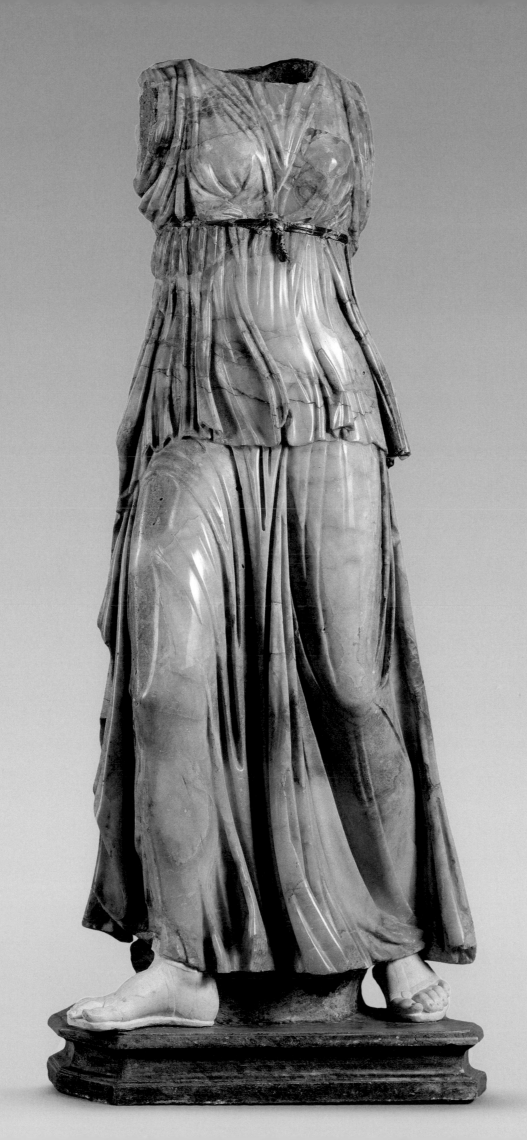

32 Statue of Apollo
Late fourth century CE
Marble, thought to be from
Göktepe, Muğla, height 55.5 cm
Acquired in 1728 from the collection of
Flavio Chigi, Rome
Inv. no. Hm 250
Lit.: Dresden Bildwerke II, cat. 140

30 Head of Apollo, Sauroctonos Type
Last quarter of the first century BCE,
after an original from circa 370–350 BCE
Fine-grained marble, height 25 cm
Acquired in 1728 from the collection of
Flavio Chigi, Rome
Inv. no. Hm 110
Lit.: Dresden Bildwerke II, cat. 121

31 Nolan Amphora: Apollo as Singer
Attic red-figure, circa 465 BCE,
Providence Painter
Terracotta, height 33 cm
Found in Nola; acquired in 1873 via the
aus'm Weerth collection from the
Sayn-Wittgenstein collection
Inv. no. Dr. 290
Lit.: CVA, 26–27, ill. 12

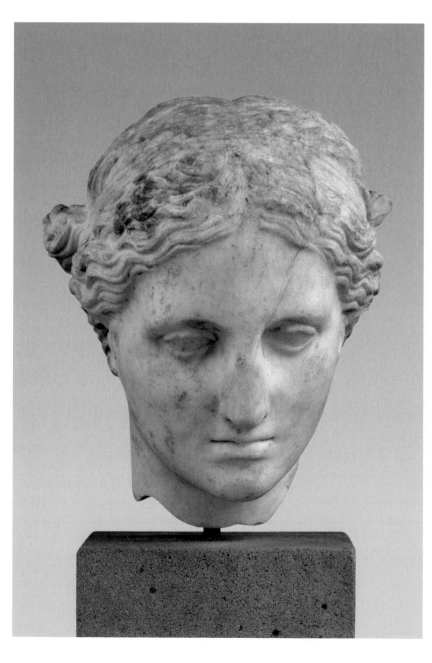

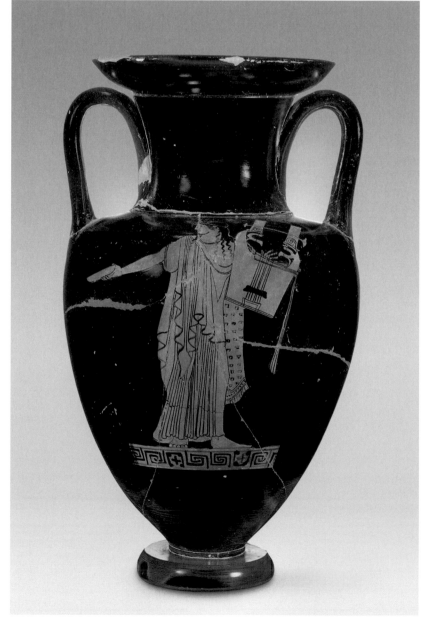

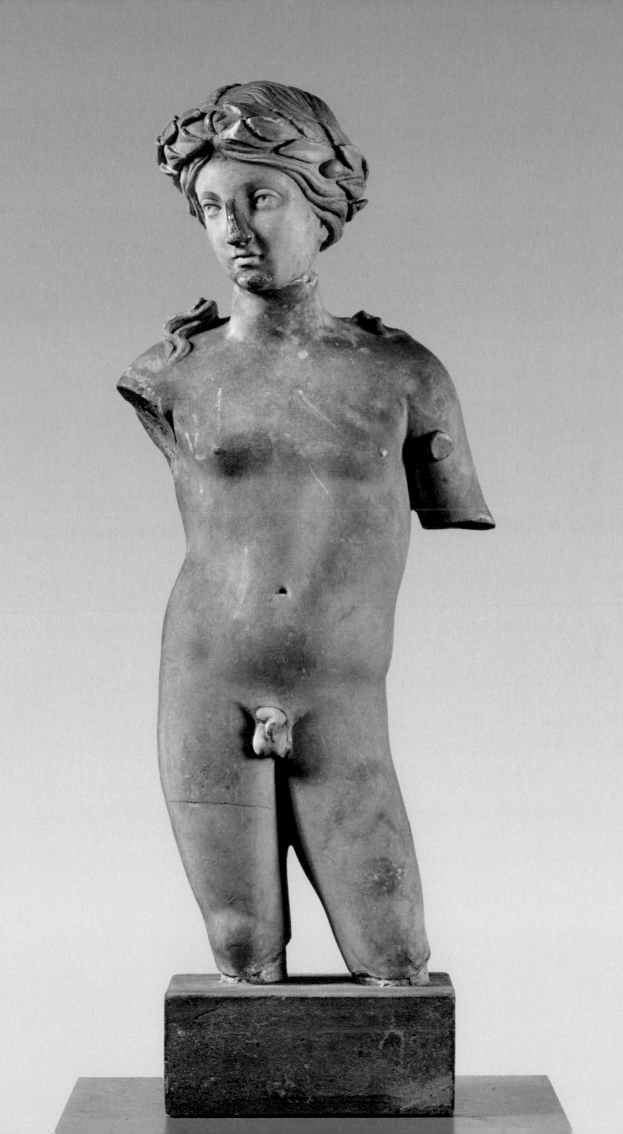

33 Squat Lekythos: Artemis Hunting
Attic red-figure, 460–450 BCE,
Karlsruhe Painter
Terracotta, height 14.6 cm
Said to be from Thebes; acquired in 1920 from
Adolf Preyss, Munich
Inv. no. ZV 2860
Lit.: CVA, 89–90, ill. 69

**34 Statue of Artemis,
Rospigliosi-Lateran Type**
Late fourth century CE, after a
pictorial schema from the mid-
second century BCE
Marble, thought to be from
Göktepe, Muğla, height 71 cm
Acquired in 1728 from the collection
of Flavio Chigi, Rome
Inv. no. Hm 270
Lit.: Dresden Bildwerke II, cat. 139

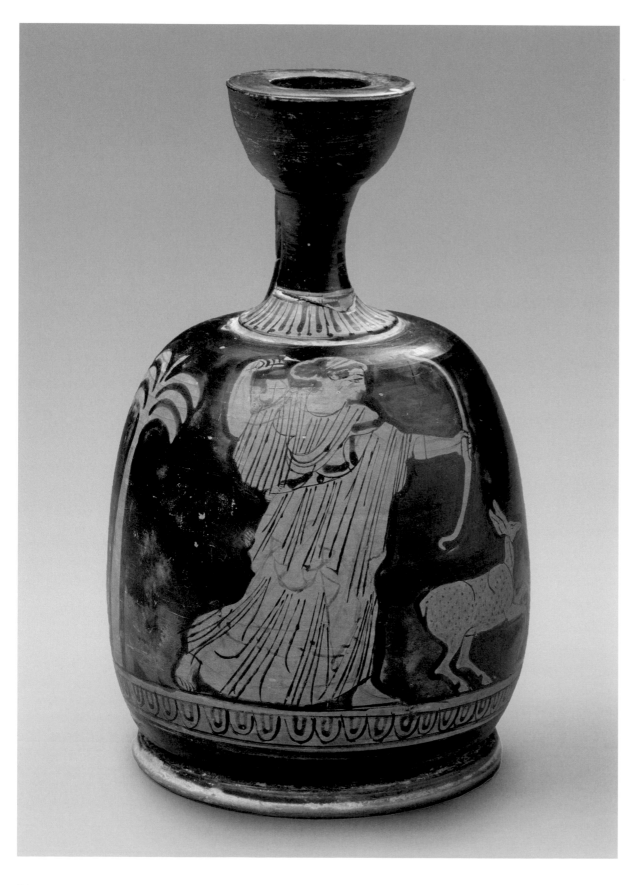

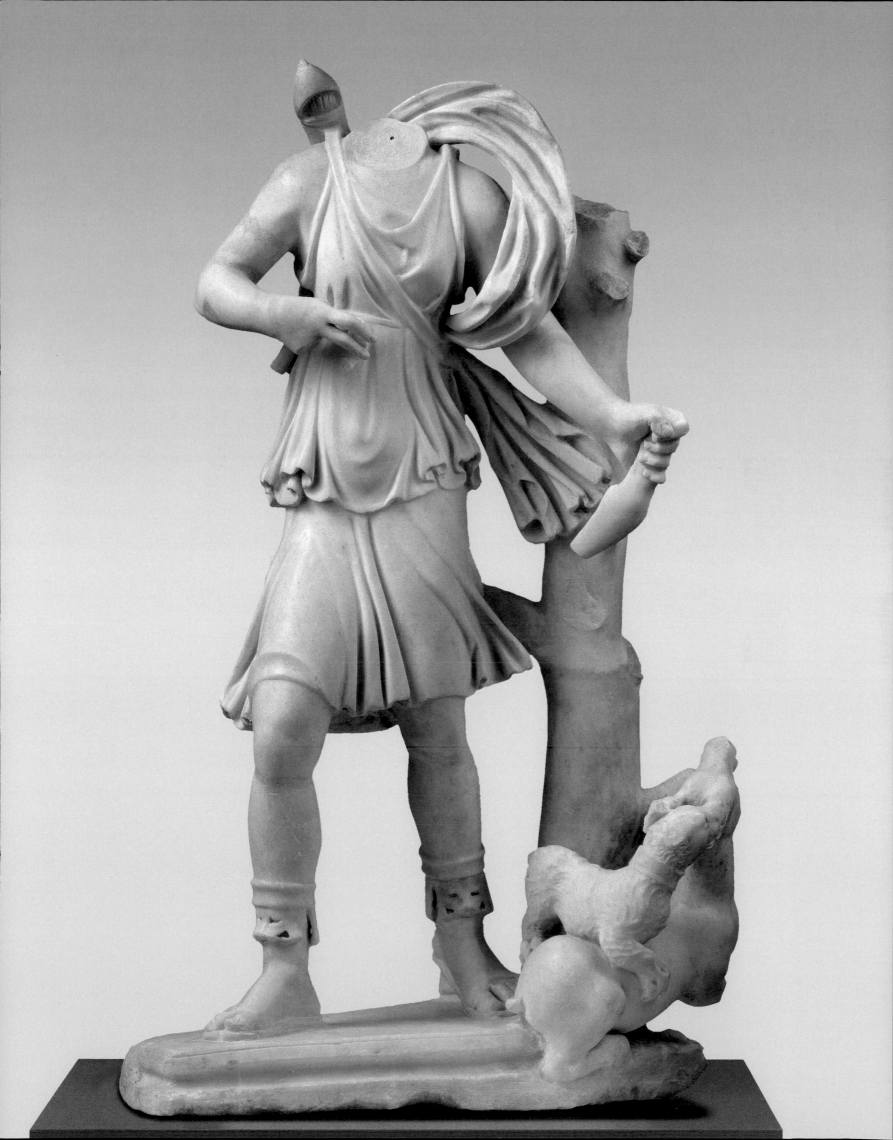

35 Pelike: Poseidon
Attic red-figure, 470–460 BCE,
Syracuse Painter
Terracotta, height 30.5 cm
Found in Nola; acquired in 1873 via
the aus'm Weerth collection from the
Sayn-Wittgenstein collection
Inv. no. Dr. 294
Lit.: CVA, 38–39, ill. 25

36 Group with Aphrodite and Triton
150–125 BCE
White marble, height 46 cm
Acquired in 1892
Inv. no. Hm 196
Lit.: Dresden Bildwerke I, cat. 49

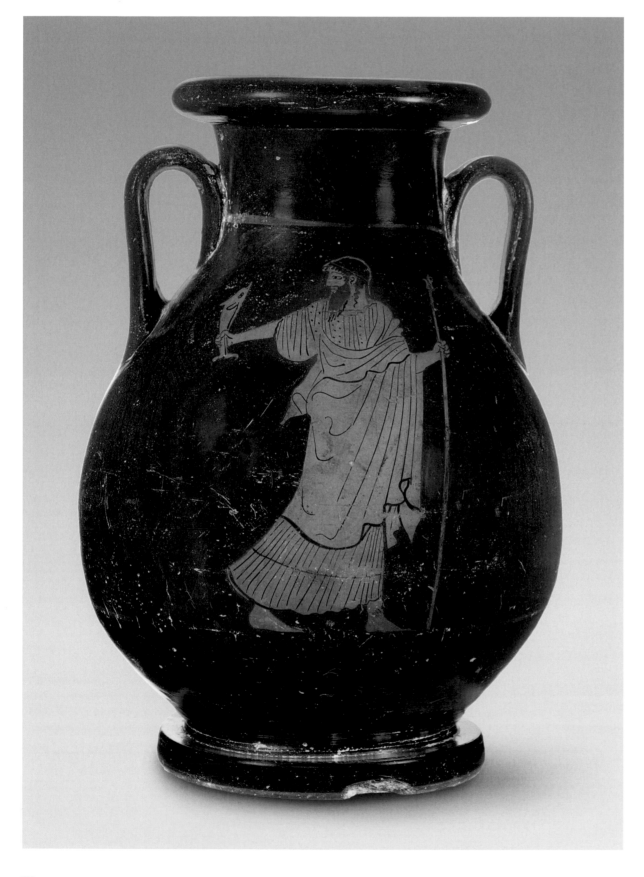

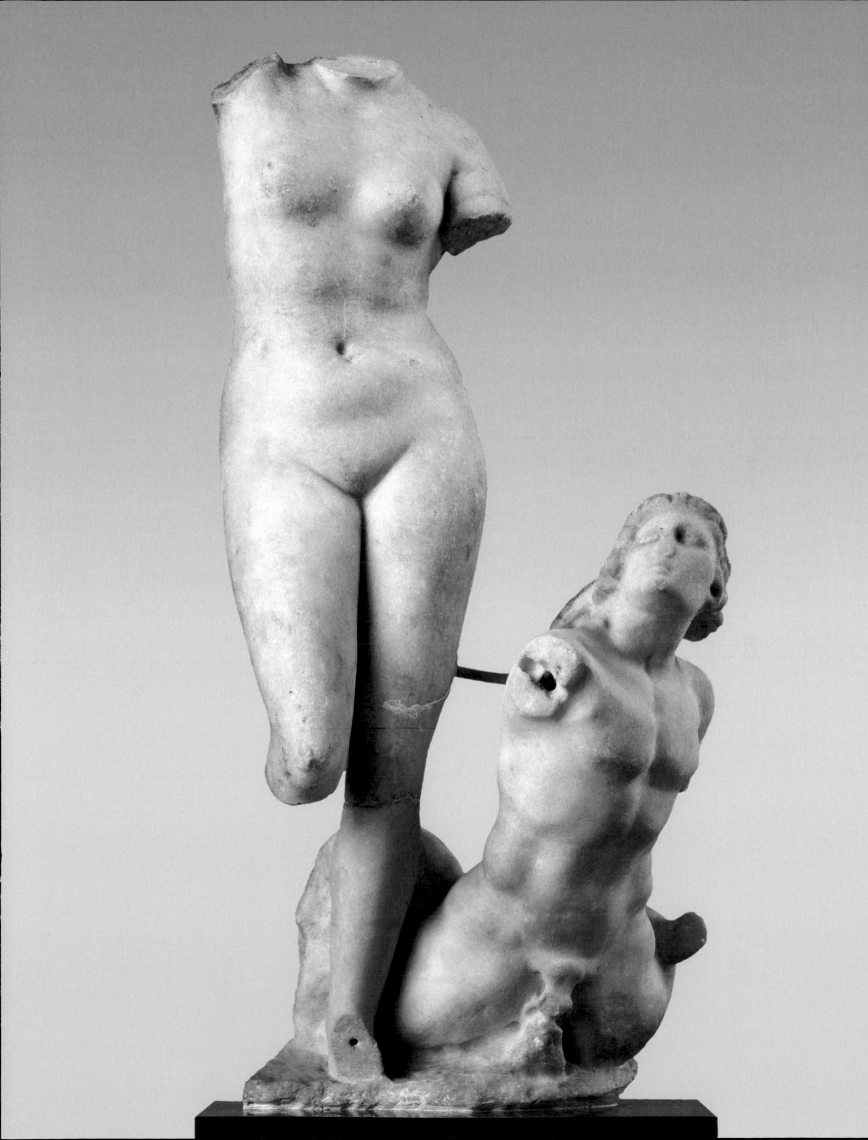

37 *Bronze Statuette of a Standing Venus*
Early Roman imperial
Solid-cast bronze, height 24.5 cm
Acquired in 1877 from the Martinetti
collection, Rome
Inv. no. ZV 30,16
Lit.: Hettner 1881, no. 64

38 *Bronze Statuette of a Leaning Venus*
Roman imperial
Solid-cast bronze, height 17.4 cm
Gifted in 1738 to Augustus III by Count
Wackerbarth-Salmour
Inv. no. AB 694
Lit.: Berlin 2001, no. F7

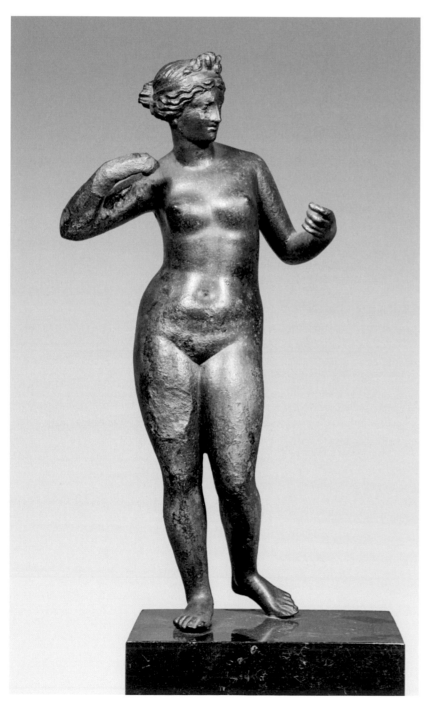

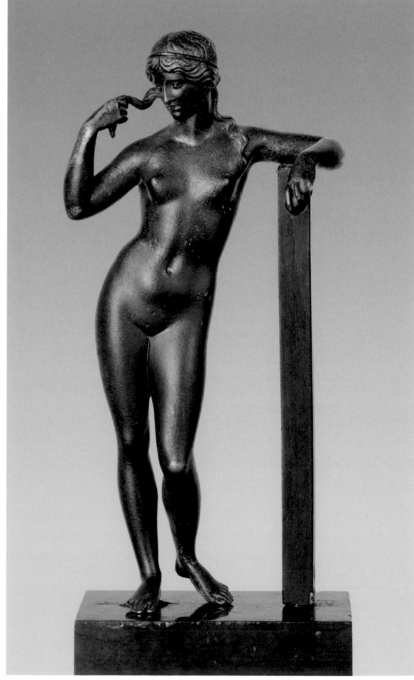

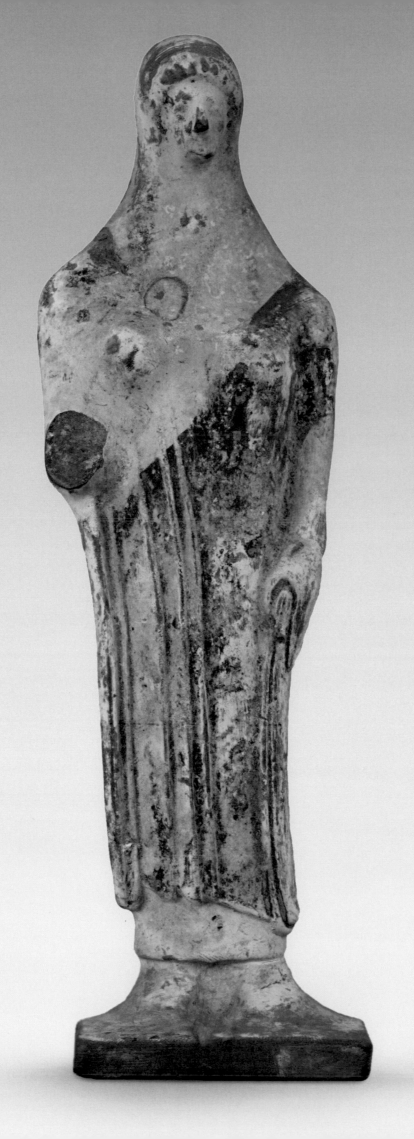

41 Bronze Statuette of Mars Ultor
First half of the second century CE
Solid-cast bronze, height 15.5 cm
Acquired in 1920 from J. W. Böhler,
Munich
Inv. no. ZV 2845
Lit.: Noelke 2012, 434, ill. 40

40 Kantharos: The Return of Hephaestus to Olympus
Boetian black-figure, second quarter
of the sixth century BCE
Terracotta, height 24.9 cm
Acquired in 1895 from Botho Graef in Athens
Inv. no. Dr. 213
Lit.: Knoll 1998, 60–61

42 Pelike: Dionysus

Attic red-figure, circa 480–470 BCE,
Tyszkiewicz Painter
Terracotta, height 27 cm
Found in Nola; acquired in 1873 via
the aus'm Weerth collection from the
Sayn-Wittgenstein collection
Inv. no. Dr. 293
Lit.: CVA, 36–38, ill. 24

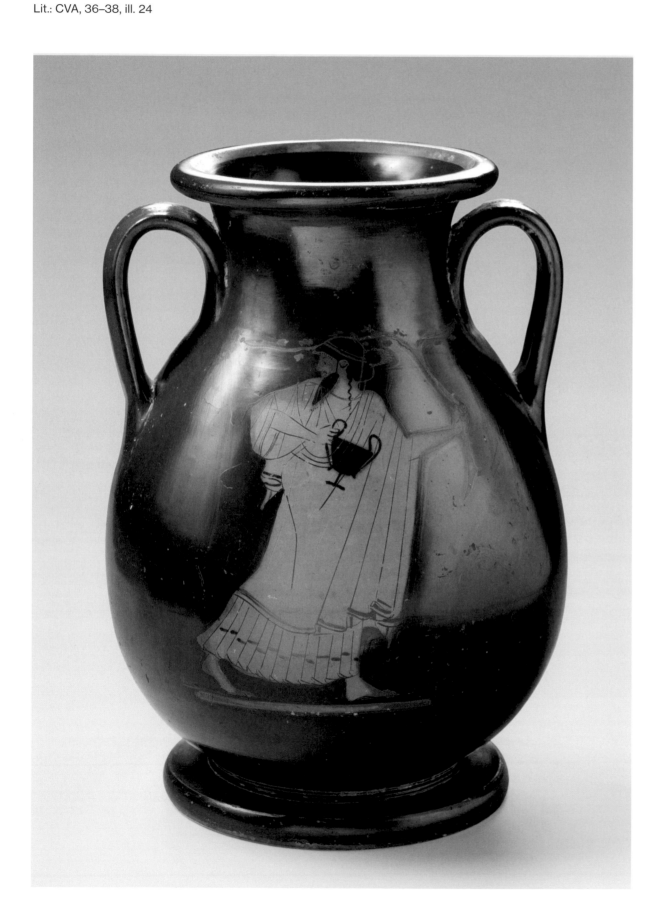

43 *Head of Dionysus*
140–150 CE
White marble, height 31 cm
Acquired in 1728 from the collection of
Flavio Chigi, Rome
Inv. no. Hm 128
Lit.: Dresden Bildwerke II, cat. 135

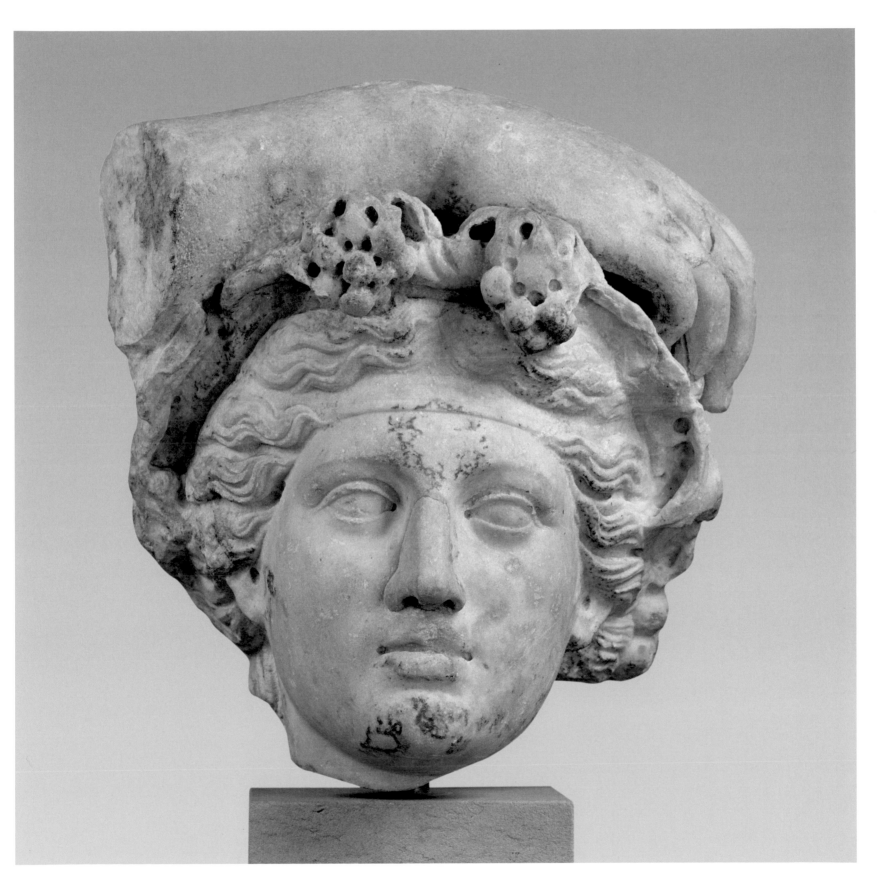

44 Kalpis: Hermes, Pursuing a Girl
Attic red-figure, 435–430 BCE, Phiale Painter
Terracotta, height 26 cm
Found in Nola; acquired in 1873 via
the aus'm Weerth collection from the
Sayn-Wittgenstein collection
Inv. no. Dr. 328
Lit.: CVA, 58–59, ill. 44

45 Herm of Hermes, Curtius B Type
First half of the first century CE, after an
original from the later fifth century BCE
White marble, height 47 cm
Acquired between 1726 and 1730 from
the Brandenburg collection of Friedrich
Frederick William; probably originally
via the Reynst collection from the
Vendramin collection, Venice
Inv. no. Hm 69
Lit.: Dresden Bildwerke II, cat. 248

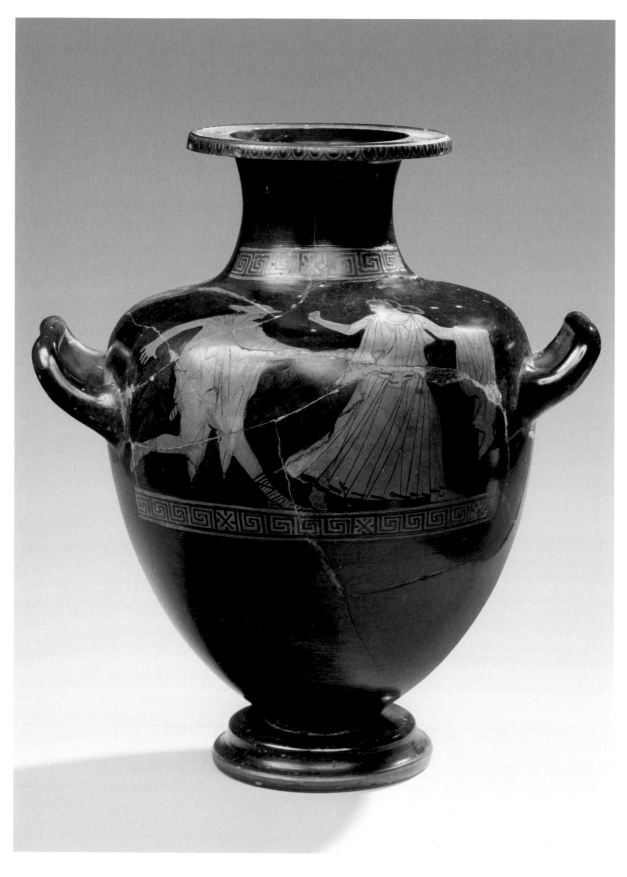

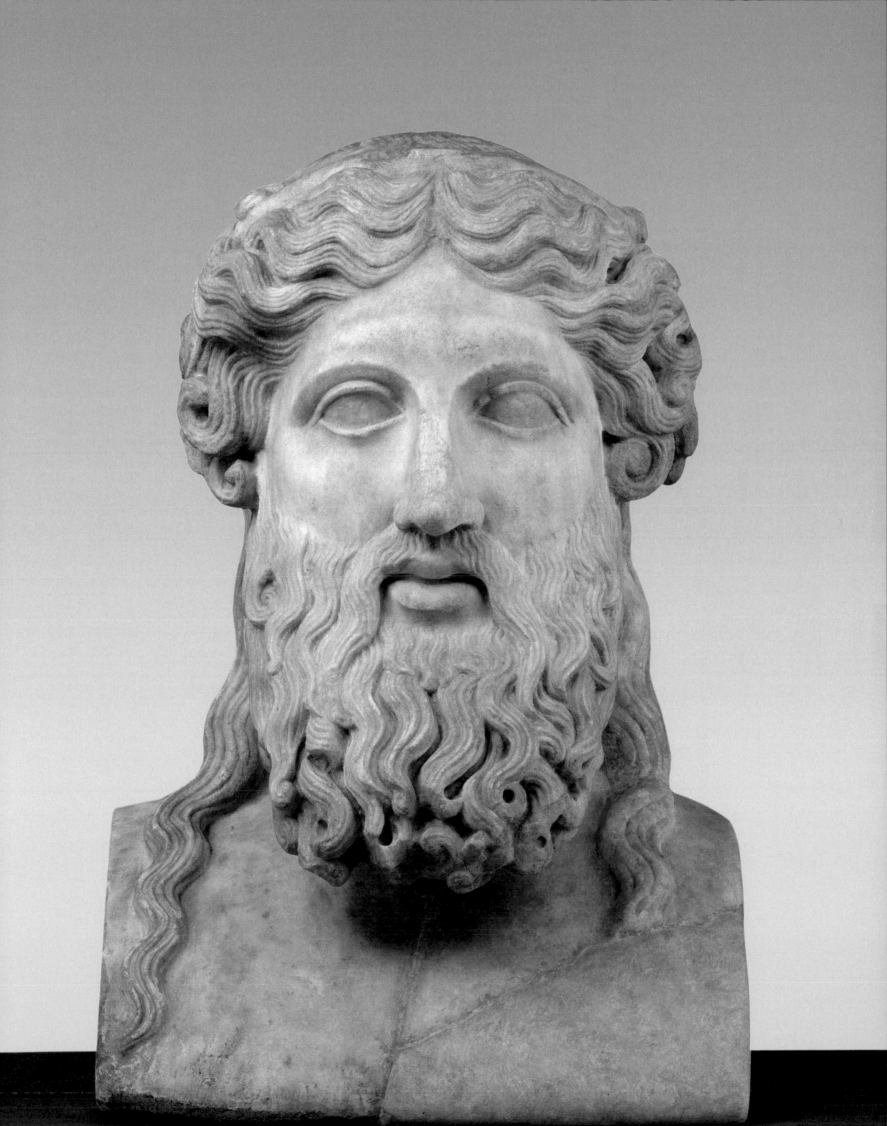

The Dresden Antiquities Collection

Kordelia Knoll

In August 1814, the archaeologist and classicist Carl August Böttiger, during one of his famous and popular talks in the Dresden antiquities gallery,[1] expressed regret that he and his audience could not share the experience of Pygmalion, whose beloved marble creation came to life and began to speak thanks to the help of the gods. It is not difficult to understand his wish. If they could only speak, what stories would the statues tell of their changing fortunes over more than two millennia—of the temples, colonnades, and libraries, of the thermae and gardens for which they were originally made! Stories of being rediscovered beneath piles of rubble and old walls, where most of them had been preserved only in fragments, to then be admired and restored, often with baroque additions. They could tell us about their role in the renaissance and baroque palaces where their proud owners once treasured them, and of their travels across Europe that led them to adorn the castles and collections of princely and royal courts.

1 Louis de Silvestre: *King Augustus II of Poland*, ca. 1723, Gemäldegalerie Alte Meister, Dresden

These artworks are a precious and inalienable legacy. They have been kept in Dresden for nearly 300 years, always in the knowledge that they represent just a fraction of a once-abundant artistic production that is now lost forever. Today the Dresden antiquities collection forms part of the collection of sculptures housed in the Albertinum on Brühl's Terrace that was created in 1887 by merging the antiquities and cast collections.[2] Having since been extended to include contemporary sculptures, it has developed into a unique sculpture museum with works from antiquity to the present. But with an antiquities collection at its core and all the variety that this entails, the museum keeps and conserves not only sculptures but also objects made of clay, bronze, ivory, glass, and gold, which today we call "small-scale antiquities."

Augustus the Strong as Collector

The collection was established in the early 1720s by Frederick Augustus I, known as Augustus the Strong. Elector of Saxony since 1694, Augustus had assumed the crown of Poland in 1697, and during the following two decades Dresden had become one of the major European capitals. In order to claim the crown, Augustus, now King Augustus II of Poland (fig. 1), had converted to Catholicism, a clever move which secured him influence at European courts as well as new opportunities to expand his art collection.

The architects and artists whom he invited to the Saxon court were inspired by his projects and visions and realized his plans: This was Saxony's "really fortunate period," as Winckelmann called it in 1755.[3] When still a young prince, Augustus had visited the cultural centers of Europe on his Grand Tour. As King of Poland he made new contacts in Vienna, Paris, and Rome, which greatly benefited his collections. He acquired Chinese and Japanese porcelain via Dutch trading posts, and through his artistic adviser, the French architect Raymond Leplat, he bought bronzes in Paris and contemporary marbles in Venice and Rome.

Of special interest to Augustus were new antiquarian finds from Rome. From 1700, envoys of the king—the cabinet minister and later Saxon-Polish field marshal Christoph August von Wackerbarth, as well as the *Ordonneur du Cabinet* Leplat—regularly traveled to the Holy City and reported back to the Saxon court. It was in this period that the first copies of antiquities came to Dresden.

But the core of the antiquities collection was formed by the sculptures of the Brandenburg collection, which Frederick William I of Prussia (reigned 1713–1740), known as the "Soldier King," presented to Augustus the Strong, a gift which was certainly not without an element of self-interest. These sculptures had been assembled by Frederick I, the Soldier King's art-loving father, but for his son they had little meaning.[4] Works from the Brandenburg collection include the Bust of Ares (cat. 12) and the Herm of Hermes (cat. 45).

Having acquired nearly 200 antiquities in Rome in 1728, Augustus built up one of the largest and most important antiquities collections outside Italy. In

1727, Pier Leone Ghezzi had informed the Saxon court of antiquities offered for sale by the Chigi family.[5] Augustus had the collection assessed, and in the summer of 1728 he sent his trusted and experienced adviser Leplat to Rome to personally examine it, negotiate a deal, and look for further objects. Works from the Chigi collection that came to Dresden include a Statue of Aphrodite (cat. 8) and a Statue of Demeter (cat. 9), as well as numerous other antiquities (cat. 16, 20, 21, 29, 30, 32, 34, 43). Leplat also successfully concluded the purchase of thirty-two sculptures from Cardinal Alessandro Albani's antiquities collection on behalf of the Saxon elector.[6] Many well-known Dresden masterworks, such as a statue of Zeus known as Dresden Zeus (cat. 2), the Athena Lemnia (cat. 4), and the so-called Dresden Artemis (cat. 6) all came from this acquisition. Leplat was praised as being "ben fornito di tutta l'intelligenza, prattica, e cognizione, che fà di bisogno in simili materie" (endowed with all the intelligence, experience and knowledge that are necessary in such matters).[7]

Antiquities in Halls and Salons

While Leplat was conducting negotiations in Rome, Augustus the Strong and his court architect Zacharias Longuelune were planning the construction of a monumental museum to house antiquities and paintings. These plans turned out to be impracticable, so Augustus decided to place the antiquities in the halls and salons of the palace in the Grand Garden in Dresden upon their arrival. At the center of a large area of parkland which at that time was outside the city walls,[8] the small palace had been built between 1679 and 1683 by the architect Johann Georg Starcke as a summer retreat and *Lustschloss* for the elector's family. Augustus the Strong, who saw himself as the incarnation of "Hercules Saxonicus" and the sun god Apollo, organized lavish festivities in this garden which were famed and praised for their originality. But once the antiquities had arrived from Rome, they took center stage in the palace. By 1730 Augustus was able to show his new collection to the Prussian king, who was staying in Dresden for the Carnival celebrations.[9] In 1747, Augustus III, son of Augustus the Strong, transferred the extensive collection into four pavilions surrounding the palace to free up space for festivities. This made it very difficult to see the antiquities, let alone examine them closely. Johann Joachim Winckelmann, who stayed in Nöthnitz near Dresden between 1748 and 1754, and in Dresden in 1755, complained about this state of affairs.[10] The three female statues from Herculaneum, bought in 1736 from the estate of Prince Eugene of Savoy, are the only antiquities described in detail in his essay "Thoughts on the Imitation of Greek Works in Painting and the Art of Sculpture."[11] Winckelmann seems to have seen hardly any of the other antiquities in Dresden.
By 1768 the installation of the statues in the pavilions had improved significantly, and the Roman sculptor and restorer Bartolomeo Cavaceppi remarked after his visit to the antiquities collection in the Grand Garden that this was the "only place that can vie in dignity with the Capitoline Hill in Rome."[12] This was an amiable exaggeration, for the Capitoline

2 Japanisches Palais, antiquities collection, view into hall 5, hall of the satyrs, ca. 1870

Museums, since opening their doors to the public in 1734, had housed the largest and most important public collection of antiquities of their day. Yet the comparison was not entirely fanciful. In terms of size, variety, and stature, the Dresden collection could certainly rival museums like the ones on Capitoline Hill, the antiquities collection acquired in 1724 by the Spanish king Philip V, and the Villa Albani, which had opened in 1763. The four pavilions surrounding the palace in the Grand Garden boasted more than 200 statues and statuettes, heads, busts, vases, sarcophagi, altars, mosaics, inscribed stones, mummies, and bronze tools.

Expansion and Scholarly Restoration of the Collection

A new era in the history of the antiquities collection began in 1786 with its transfer to the Japanisches Palais, which lies directly on the banks of the Elbe in the Neustadt district of Dresden. In ten first-floor rooms, all open to the public,

3 A collection of original sculptures in the Albertinum, hall of the four warriors, 1905

the collection could be extensively displayed for the first time (fig. 3). As the guest books show, many of the most important figures of the time, including Gotthold Ephraim Lessing, Friedrich Schiller, Johann Wolfgang von Goethe, and the Humboldt and Schlegel families, were among the visitors.

From 1784 the cast collection, which the Saxon court had purchased from the estate of Anton Raphael Mengs in Rome, was also housed in Dresden. It quickly became one of the most popular attractions in the city[13] and expanded steadily over the next decades.

But unlike its counterparts in Berlin or

Munich, which opened in 1830 and acquired global fame thanks to their new acquisitions, the Dresden museum did not buy any more ancient sculptures. This was a time of serious political and economic instability in Saxony, and Dresden was unable to compete with the grandiose acquisitions of King Ludwig in Munich and the Prussian kings in Berlin. It was only in the 1870s, when the unification of Germany brought political consolidation and economic growth, that the antiquities collection could be revitalized. Most of its small-scale antiquities, especially bronzes and vases, were assembled at that time (cat. 17–19, 22, 24–26, 33, 37–42, 44).

At the turn of the twentieth century, new spatial arrangements in the Albertinum for the antiquities and cast collections and the works of contemporary sculptors gave the antiquities collection a new lease of life.[14] During Georg Treu's directorship of the museum, additions from baroque restorations, which often distorted the originals, were removed, a decision which helped to enhance the collection's aesthetic and scholarly value.

The events of World War II did not leave the sculpture collection untouched, and it took more than twenty years for the postwar situation to stabilize. It was only in 1969 that a selection of ancient sculptures, vases, bronzes, and terracottas could once more be displayed in a permanent exhibition. After the disastrous floods of 2002, the Albertinum was thoroughly refurbished, and its collections were reorganized before the reopening. As a museum of modern art, it now accommodates works from the romantic period to the present day. Joining the Gemäldegalerie Alte Meister, the antiquities will soon find their final home in the Semperbau.

1 Böttiger 1814.
2 For the history of the collection see Dresden 1994; Knoll 2009; Knoll 2011; Knoll 2017.
3 Winckelmann 2013, 31.
4 Heres 1977; Heres 2000; Martin 2013, especially 7–26.
5 For the story of the acquisition see Zimmermann 1977b; Cacciotti 2004; Cacciotti 2009.
6 Röttgen 1982; Cacciotti 1999.
7 In the opinion of Alessandro Albani, quoted in Cacciotti 2004, 62.
8 Blanke 2000.
9 Heres 1978-79, 109.
10 Johann Joachim Winckelmann famously commented on the inadequate space and conditions in which the antiquities were kept: "The greatest treasury of antiquities is to [be] found in Dresden. [...] However, I cannot provide details of the most excellent qualities of their beauty, because the best statues were standing in a shed made of boards, packed together like herrings." In Winckelmann 2013, 159. See also Zimmermann 1977a.
11 "Thoughts on the Imitation of Greek Works in Painting and the Art of Sculpture," in Winckelmann 2013, 31–55.
12 Quoted in Daßdorf 1782, 552–53.
13 Kiderlen 2006; Knoll 2012.
14 Dresden 1994.

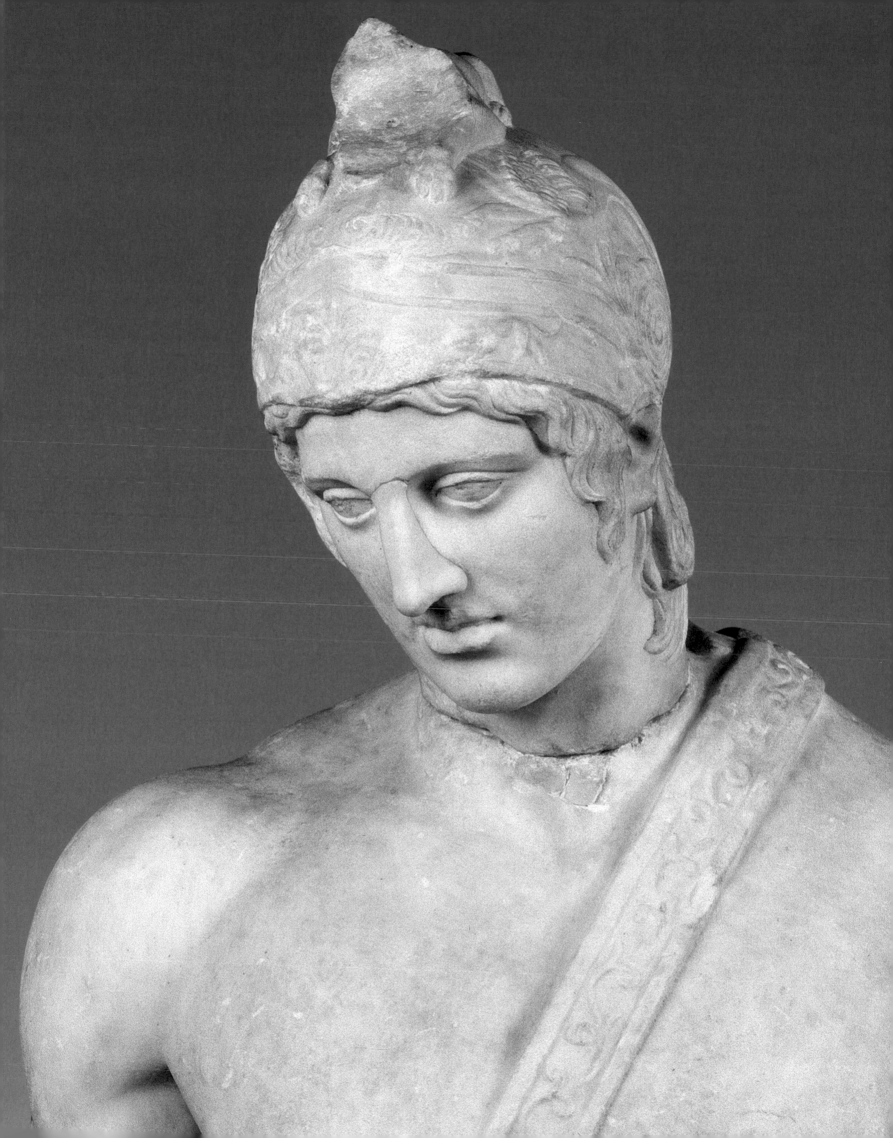

Selected Bibliography

Agnoli 2002
Agnoli, Nadia. *Museo Archeologico Nazionale di Palestrina. Le sculture*. Rome, 2002.

Bartsch et al. 2010
Bartsch, Tatjana, et al, eds. *Das Originale der Kopie. Kopien als Produkte und Medien der Transformation von Antike*. Berlin, 2010.

Berlin 1994
Standorte. Kontext und Funktion antiker Skulptur. Berlin: Abguss-Sammlung Antiker Plastik des Seminars für Klassische Archäologie an der Freien Universität, 1994. Exhibition catalog.

Berlin 2001
In den Gärten der Aphrodite. Berlin: Abguss-Sammlung Antiker Plastik des Instituts für Klassische Archäologie an der Freien Universität, 2001. Exhibition catalog.

Berlin 2002
Die griechische Klassik. Idee oder Wirklichkeit. Berlin: Martin-Gropius-Bau, 2002. Exhibition catalog.

Bernhardt 2003
Bernhardt, Rainer. *Luxuskritik und Aufwandsbeschränkungen in der griechischen Welt*, Stuttgart, 2003.

Blanke 2000
Blanke, Harald. *Der Große Garten zu Dresden. Geschichte und Gestaltung im Zeitalter Augusts des Starken 1676–1733*. 2 vols. Dresden, 2000.

Böttiger 1838
Böttiger, Carl August. "Ueber die Dresdener Antiken-Galerie. Eine Vorlesung, im Vorsaale derselben gehalten den 31. August 1814," in Böttiger, *Kleine Schriften archäologischen und antiquarischen Inhalts*, edited by Julius Sillig, vol. 2. Dresden/Leipzig, 1838, 25–52.

Bonn 1989
Herrscher und Athlet. Die Bronzen vom Quirinal. Bonn: Akademisches Kunstmuseum, 1989. Exhibition catalog.

Borbein 1973
Borbein, Adolf Heinrich. "Die griechische Statue des 4. Jahrhunderts v. Chr.," *Jahrbuch des Deutschen Archäologischen Instituts* 88 (1973): 43–212.

Boschung/Jäger 2014
Boschung, Dietrich and Ludwig Jäger, eds. *Formkonstanz und Bedeutungswandel*. Paderborn 2014.

Bremmer 2012
Bremmer, Jan N. "The Agency of Greek and Roman Statues: From Homer to Constantine," *Opuscula: Annual of the Swedish School at Athens and Rome* 6 (2012): 7–21.

Brinke 1991
Brinke, Margit. *Kopienkritische und typologische Untersuchungen zur statuarischen Überlieferung der Aphrodite Typus Louvre-Neapel*. Hamburg, 1991.

Buchheim 1986
Buchheim, Thomas. *Die Sophistik als Avantgarde normalen Lebens*. Hamburg, 1986.

Burckhardt 1998
Burckhardt, Jacob. *The Greeks and Greek Civilization*, edited by Oswyn Murray. New York, 1998.

Buxton 1994
Buxton, Richard G. A. *Imaginary Greece: The Contexts of Mythology*. Cambridge, 1994.

Cacciotti 1999
Cacciotti, Beatrice. Nuovi documenti sulla prima collezione del cardinale Alessandro Albani, *Bollettino dei Musei Comunali di Roma* 13 (1999): 41–69.

Cacciotti 2004
Cacciotti, Beatrice. *La collezione di antichità del cardinale Flavio Chigi*, Rome 2004.

Cacciotti 2009
Cacciotti, Beatrice. "Kunsthändler, Antiquare und Antikensammler in Rom zwischen 1700 und 1733," in Dresden 2009, 96–105.

Cain 1998
Cain, Hans-Ulrich. "Copie dai 'mirabilia' greci," in *I Greci. Storia, cultura, arte, società*, vol. 2.3: *Una storia greca. Trasformazioni*, edited by Salvatore Settis. Turin, 1998, 1221–44.

Chaniotis 2017
Chaniotis, Angelos. "The Life of Statues: Emotion and Agency," in *Emotions in the Classical World: Methods, Approaches, and Directions*, edited by Douglas Cairns and Damien Nelis. Stuttgart, 2017, 141–58.

Clements 2016
Clements, Jacquelyn H. "The Terrain of Autochthony: Shaping the Athenian Landscape in the Late Fifth Century B.C.E.," in *The Routledge Handbook of Identity and the Environment in the Classical and Medieval Worlds*, edited by Rebecca Futo Kennedy and Molly Jones-Lewis. London, 2016, 315–40.

CVA
Corpus vasorum antiquorum, vol. 97: *Dresden, Staatliche Kunstsammlungen, Skulpturensammlung*, vol. 2: *Attisch rotfigurige Keramik*, edited by Eva Hofstetter-Dolega. Munich, 2015.

Daßdorf 1782
Daßdorf, Karl Wilhelm. *Beschreibung der vorzüglichsten Merkwürdigkeiten der Churfürstlichen Residenzstadt Dresden und einiger umliegender Gegenden*. Dresden, 1782.

DNO
Der Neue Overbeck. Die antiken Schriftquellen zu den bildenden Künsten der Griechen. 5 vols. Berlin, 2014.

Dresden 1994
Das Albertinum vor 100 Jahren – die Skulpturensammlung Georg Treus. Dresden: Albertinum, 1994. Exhibition catalog.

Dresden 2000
Götter und Menschen. Antike Meisterwerke der Skulpturensammlung, Staatliche Kunstsammlungen Dresden. Dresden: Albertinum, 2000. Exhibition catalog.

Dresden 2009
Verwandelte Götter. Antike Skulpturen des Museo del Prado zu Gast in Dresden. Dresden: Japanisches Palais, 2009. Exhibition catalog.

Dresden Bildwerke I
Skulpturen von der ägäischen Frühzeit bis zum Ende des Hellenismus, Skulpturensammlung Staatliche Kunstsammlungen Dresden, Katalog der antiken Bildwerke I, edited by Kordelia Knoll and Christiane Vorster. Munich, 2017.

Dresden Bildwerke II
Idealskulptur der römischen Kaiserzeit, Skulpturensammlung Staatliche Kunstsammlungen Dresden, Katalog der antiken Bildwerke II, edited by Kordelia Knoll, Christiane Vorster, and Moritz Woelk. 2 vols. Munich, 2011.

Dresden Bildwerke III
Die Porträts, Skulpturensammlung Staatliche Kunstsammlungen Dresden, Katalog der antiken Bildwerke III, edited by Kordelia Knoll and Christiane Vorster. Munich 2013.

Dresden Bildwerke IV
Römische Reliefs, Geräte und Inschriften, Skulpturensammlung Staatliche Kunstsammlungen Dresden, Katalog der antiken Bildwerke IV, edited by Kordelia Knoll and Christiane Vorster, Munich, 2018.

Dunbabin 1999
Dunbabin, Katherine M. D. Mosaics of the Greek and Roman World. Cambridge, 1999.

Ewald 2008
Ewald, Björn Christian. "Christopher H. Hallett: The Roman Nude," The Art Bulletin 90.2 (2008): 286–91.

Fabricius 2001
Fabricius, Johanna. "Verweiblichung und Verweichlichung. Zu männlichen und weiblichen Körperkonzepten in der griechischen Kultur," in Geschlecht weiblich. Körpererfahrungen – Körperkonzepte, edited by Carmen Franz and Gudrun Schwibbe. Berlin, 2001, 35–83.

Fabricius 2007
Fabricius, Johanna. "Grenzziehungen. Zu Strategien somatischer Geschlechterdiskurse in der griechischen und römischen Kultur," in Geschlechterdefinitionen und Geschlechtergrenzen in der Antike, edited by Elke Hartmann et al. Stuttgart, 2007, 65–86.

Faedo 1994
Faedo, Lucia. "Mousa, Mousai," in Lexicon iconographicum mythologiae classicae, vol. 7, Munich/Zurich 1994.

Foucault 1985
Foucault, Michel. The History of Sexuality, vol 2: The Use of Pleasure. New York, 1985.

Frankfurt 2013
Zurück zur Klassik. Ein neuer Blick auf das alte Griechenland. Frankfurt am Main: Liebieghaus Skulpturensammlung, 2013. Exhibition catalog.

Gaifman 2006
Gaifman, Milette. "Statue, Cult and Reproduction," Art History 29 (2006): 258–79.

Gazda 2002
Gazda, Elaine K. The Ancient Art of Emulation: Studies in Artistic Originality and Tradition From the Present to Classical Antiquity. Ann Arbor, MI, 2002.

Geominy 1999
Geominy, Wilfred. "Zwischen Kennerschaft und Cliché. Römische Kopien und die Geschichte ihrer Bewertung," in Rezeption und Identität. Die kulturelle Auseinandersetzung Roms mit Griechenland als europäisches Paradigma, edited by Gregor Vogt-Spira and Bettina Rommel, Stuttgart 1999, 38–59.

Graf 1991
Graf, Fritz. Griechische Mythologie. Eine Einführung. Munich, 1991.

Graf 1993
Graf, Fritz. Greek Mythology: An Introduction. Baltimore/London, 1993.

Hallett 2005
Hallett, Christopher H. "Emulation versus Replication: Redefining Roman Copying," Journal of Roman Archaeology 18 (2005): 419–35.

Hamburg 2007
Bunte Götter. Die Farbigkeit antiker Skulptur. Hamburg: Museum für Kunst und Gewerbe, 2007. Exhibition catalog.

Gods in Color: Painted Sculpture of Classical Antiquity. Cambridge, MA: Harvard University Art Museum, 2007. Exhibition catalog.

Havelock 1995
Havelock, Christine Mitchell. The Aphrodite of Knidos and Her Successors: A Historical Review of the Female Nude in Greek Art. Ann Arbor, MI, 1995.

Heres 1977
Heres, Gerald. "Die Anfänge der Berliner Antiken-Sammlung. Zur Geschichte des Antikenkabinetts 1640–1830," Staatliche Museen zu Berlin. Forschungen und Berichte 18 (1977): 93–129.

Heres 1978/79
Heres, Gerald. "Die Dresdener Sammlungen in Keyßlers 'Neuesten Reisen,'" Jahrbuch der Staatlichen Kunstsammlungen Dresden 11 (1978/79): 101–16.

Heres 2000
Heres, Gerald. "Bellori collezionista. Il Museum Bellorianum," in L'Idea del Bello. Viaggio per Roma nel Seicento con Giovan Pietro Bellori. Rome: Palazzo delle Esposizioni, 2000, 499–501. Exhibition catalog.

Hettner 1857
Hettner, Hermann. Das Königliche Museum der Gypsabgüsse zu Dresden. Dresden, 1857.

Hettner 1881
Hettner, Hermann. Die Bildwerke der Königlichen Antikensammlung zu Dresden, 4th edition, Dresden 1881.

Hölscher 1987
Hölscher, Tonio. Römische Bildsprache als semantisches System. Heidelberg, 1987.

Hölscher 1998
Hölscher, Tonio. Aus der Frühzeit der Griechen. Räume—Körper—Mythen. Stuttgart, 1998.

Hölscher 2003
Hölscher, Tonio. "Körper, Handlung und Raum als Sinnfiguren in der griechischen Kunst und Kultur," in Sinn (in) der Antike. Orientierungssysteme, Leitbilder und Wertkonzepte im Altertum, edited by Karl-Joachim Hölkerkamp. Mainz, 2003, 163–92.

Hölscher 2004
Hölscher, Tonio. The Language of Roman Art. Cambridge, 2004.

Hölscher 2007
Hölscher, Tonio. Die griechische Kunst. Munich, 2007.

T. Hölscher 2017
Hölscher, Tonio. Die Geschöpfe des Daidalos. Vom sozialen Leben der griechischen Bildwerke. Heidelberg, 2017.

F. Hölscher 2017
Hölscher, Fernande. Die Macht der Gottheit im Bild. Archäologische Studien zur griechischen Götterstatue. Heidelberg, 2017.

Junker 2012
Junker, Klaus. Götter als Erfinder. Die Entstehung der Kultur in der griechischen Kunst. Darmstadt, 2012.

Junker/Stähli 2008
Original und Kopie. Formen und Konzepte der Nachahmung in der antiken Kunst, edited by Klaus Junker and Adrian Stahli with Christian Kunze. Wiesbaden, 2008.

Kiderlen 2006

Kiderlen, Moritz. *Die Sammlung der Gipsabgüsse von Anton Raphael Mengs in Dresden. Katalog der Abgüsse, Rekonstruktionen, Nachbildungen und Modelle aus dem römischen Nachlaß des Malers in der Skulpturensammlung, Staatliche Kunstsammlungen Dresden.* Munich, 2006.

Knoll et al. 1993

Knoll, Kordelia, Heiner Protzmann, and Ingeborg Raumschüssel. *Die Antiken im Albertinum. Staatliche Kunstsammlungen Dresden. Skulpturensammlung.* Mainz, 1993.

Knoll 1998

Knoll, Kordelia. *Alltag und Mythos. Griechische Gefäße der Skulpturensammlung.* Leipzig, 1998.

Knoll 2009

Knoll, Kordelia. "Die Dresdner Sammlung im 18. Jahrhundert und ihre Entwicklung bis heute," in Dresden 2009, 108–21.

Knoll 2011

Knoll, Kordelia. "Geschichte der 'Churfürstlichen Antiken-Galerie in Dresden,'" in Dresden Bildwerke II, vol. 1, 1–15.

Knoll 2012

Knoll, Kordelia. "Von der 'künstlerisch vollendeten' Aufstellung zum wissenschaftlich-didaktischen Abgussmuseum. Die Entwicklung der Dresdener Abguss-Sammlung im 19. Jahrhundert," in *Gipsabgüsse und antike Skulpturen. Präsentation und Kontext,* edited by Charlotte Schreiter. Berlin, 2012, 301–15.

Knoll 2017

Knoll, Kordelia. "Die Dresdner Antikensammlung im 19. und frühen 20. Jahrhundert unter besonderer Berücksichtigung der Erwerbung antiker Skulpturen," in Dresden Bildwerke I, 33–57.

Kousser 2007

Kousser, Rachel. "Mythological Group Portraits in Antonine Rome: The Performance of Myth," *American Journal of Archaeology* 111 (2007): 673–91.

Kristensen/Stirling 2016

Kristensen, Troels Myrup and Lea Stirling, eds. *The Afterlife of Greek and Roman Sculpture: Late Antique Responses and Practices.* Ann Arbor, MI, 2016.

Landwehr 1985

Landwehr, Christa. *Die antiken Gipsabgüsse aus Baiae. Griechische Bronzestatuen in Abgüssen römischer Zeit.* Berlin, 1985.

Lee 2015

Lee, Mireille. "Other 'Ways of Seeing': Female Viewers of the Knidian Aphrodite," *Helios* 42 (2015): 103–22.

Liverani 2010

Liverani, Paolo. "New Evidence on the Polychromy of Roman Sculpture," in *Circumlitio: The Polychromy of Antique and Mediaeval Sculpture,* edited by Vinzenz Brinkmann et al. Munich 2010, 290–302.

Marvin 2008

Marvin, Miranda. *The Language of the Muses: The Dialogue Between Roman and Greek Sculpture.* Los Angeles, CA, 2008.

Mikalson 2003

Mikalson, Jon D. *Herodotus and Religion in the Persian Wars.* Chapel Hill, NC, 2003.

Nagel/Wood 2005

Nagel, Alexander and Christopher S. Wood. "Toward a New Model of Renaissance Anachronism," *The Art Bulletin* 87 (2005): 403–15.

Nagel/Wood 2010

Nagel, Alexander and Christopher S. Wood. *Anachronic Renaissance.* New York, 2010.

Naumann-Stecker 2015

Naumann-Stecker, Friederike. "Skulpturen nach der Athena Parthenos in den Provinzen," in *Römische Götterbilder der mittleren und späten Kaiserzeit,* edited by Dietrich Boschung and Alfred Schäfer. Paderborn, 2015, 13–39.

Neer 2010

Neer, Richard T. *The Emergence of the Classical Style in Greek Sculpture.* Chicago, IL, 2010.

Neumann 2004

Neumann, Gerhard. "Das Rätsel der Athena Lemnia," *Mitteilungen des Deutschen Archäologischen Instituts. Athenische Abteilung* 119 (2004): 221–38.

Noelke 2012

Noelke, Peter. "Kaiser, Mars oder Offizier? Eine Kölner Panzerstatue und die Gattung der Ehrenstatuen in den nördlichen Grenzprovinzen des Imperium Romanum," *Jahrbuch des Römisch-Germanischen Zentralmuseums Mainz* 59 (2012): 391–512.

Ostwald 1995

Ostwald, Martin. "Freedom and the Greeks," in *The Origins of Modern Freedom in the West,* edited by Richard W. Davis. Stanford, CA, 1995, 35–63.

Palagia/Pollitt 1998

Palagia, Olga and Jerome J. Pollitt, eds. *Personal Styles in Greek Sculpture.* Cambridge, 1998.

Perry 2005

Perry, Ellen. *The Aesthetics of Emulation in the Visual Arts of Ancient Rome.* Cambridge, 2005.

Pollitt 1972

Pollitt, Jerome J. *Art and Experience in Classical Greece.* Cambridge, 1972.

Pollitt 1978

Pollitt, Jerome J. "The Impact of Greek Art on Rome," *Transactions of the American Philological Association* 108 (1978): 155–74.

Raaflaub 2004

Raaflaub, Kurt. *The Discovery of Freedom in Ancient Greece.* Chicago, IL, 2004.

Raumschüssel 1966

Raumschüssel, Martin. "Skulpturensammlung," in *Skulpturensammlung, Münzkabinett, Grünes Gewölbe. Bildwerke der Renaissance und des Barocks.* Dresden 1966, 9–64.

Ridgway 1984

Ridgway, Brunilde Sismondo. *Roman Copies of Greek Sculpture: The Problem of the Originals.* Ann Arbor, MI, 1984.

Röttgen 1982
Röttgen, Steffi. "Alessandro Albani," in *Forschungen zur Villa Albani. Antike Kunst und die Epoche der Aufklärung*, edited by Herbert Beck, Berlin 1982, 123–52.

Scheer 2000
Scheer, Tanja Susanne. *Die Gottheit und ihr Bild. Untersuchungen zur Funktion griechischer Kultbilder in Religion und Politik.* Munich, 2000.

Scholz 2006
Scholz, Peter. "Bios philosophikos. Soziale Bedingungen und institutionelle Voraussetzungen des Philosophierens in klassischer und hellenistischer Zeit," *Wissen und Bildung in der antiken Philosophie*, edited by Christof Rapp and Tim Wagner. Stuttgart, 2006, 37–58.

Scodel 2017
Scodel, Ruth. "Homeric Fate, Homeric Poetics," in *The Winnowing Oar: New Perspectives in Homeric Studies*, edited by Christos Tsagalis and Andreas Markantonatos. Berlin, 2017, 75–93.

Simon 1985
Simon, Erika. *Die Götter der Griechen.* Munich, 1985.

Sissa/Detienne 2000
Sissa, Giulia and Marcel Detienne. *The Daily Life of the Greek Gods.* Stanford, CA, 2000.

Stähli 2001
Stähli, Adrian. "Der Körper, das Begehren, die Bilder. Visuelle Strategien der Konstruktion einer homosexuellen Männlichkeit," in *Konstruktionen von Wirklichkeit. Bilder im Griechenland des 5. und 4. Jahrhunderts v. Chr.*, edited by Ralf von den Hoff and Stefan Schmidt. Stuttgart, 2001, 197–209.

Steiner 2001
Steiner, Deborah. *Images in Mind: Statues in Archaic and Classical Greek Literature and Thought.* Princeton, 2001.

Stewart 1997
Stewart, Andrew. *Art, Desire, and the Body in Ancient Greece.* Cambridge, 1997.

Stewart 2008
Stewart, Andrew. *Classical Greece and the Birth of Western Art.* Cambridge, 2008.

Stewart 2010
Stewart, Andrew. "A Tale of Seven Nudes: The Capitoline and Medici Aphrodites, Four Nymphs at Elean Herakleia, and an Aphrodite at Megalopolis," *Antichthon* 44 (2010): 12–32.

Stewart 2014
Stewart, Andrew. *Art in the Hellenistic World.* New York, 2014.

Stewart 2016
Stewart, Andrew. "The Borghese Ares Revisited: New Evidence From the Agora and a Reconstruction of the Augustan Cult Group in the Temple of Ares," *Hesperia* 85 (2016): 577–625.

Stirling 2005
Stirling, Lea M. *The Learned Collector: Mythological Statuettes and Classical Taste in Late Antique Gaul.* Ann Arbor, MI, 2005.

Tanner 2006
Tanner, Jeremy. *The Invention of Art History in Ancient Greece: Religion, Society and Artistic Rationalisation.* London, 2006.

Trimble/Elsner 2006
Trimble, Jennifer and Ja Elsner, eds. *Art and Replication: Greece, Rome and Beyond.* Hoboken, 2006.

Vernant 2001
Vernant, Jean-Pierre. *The Universe, the Gods, and Mortals: Ancient Greek Myths.* London, 2001.

Veyne 1988
Veyne, Paul. *Did the Greeks Believe in Their Myths? An Essay on the Constitutive Imagination.* Chicago, IL, 1988.

Whitmarsh 2015
Whitmarsh, Tim. *Battling the Gods: Atheism in the Ancient World.* New York, 2015.

Winckelmann 1968
Winckelmann, Johann Joachim. *Kleine Schriften, Vorreden, Entwürfe*, edited by Walther Rehm. Berlin, 1968.

Winckelmann 2013
Johann Joachim Winckelmann on Art, Architecture and Archaeology. Rochester, NY, 2013.

Winter 1903
Winter, Franz. *Die Typen der figürlichen Terrakotten. Die antiken Terrakotten*, vol. 3.2, edited by Reinhard Kekulé von Stradonitz. Berlin/Stuttgart, 1903.

Wrede 1971
Wrede, Henning. "Das Mausoleum der Claudia Semne und die bürgerliche Plastik der Kaiserzeit", in *Mitteilungen des Deutschen Archäologischen Instituts. Römische Abteilung* 78 (1971): 125–66.

Wrede 1981
Wrede, Henning. *Consecratio in formam deorum. Vergöttlichte Privatpersonen in der römischen Kaiserzeit.* Mainz, 1981.

Zanker 1974
Zanker, Paul. *Klassizistische Statuen. Studien zur Veranderung des Kunstgeschmacks in der römischen Kaiserzeit.* Mainz, 1974.

Zanker 2002
Zanker, Paul. "Imitazione e riproduzione come destino culturale," in *Un'arte per l'impero. Funzione e intenzione delle immagini nel mondo romano*, edited by Eugenio Polito. Milan, 2002, 92–111.

Zanker 2005
Zanker, Paul. "Der Boxer," in *Meisterwerke der antiken Kunst*, edited by Luca Giuliani, Munich 2005, 28–49.

Zanker 2007
Zanker, Paul. *Die römische Kunst.* Munich, 2007.

Zanker 2010
Zanker, Paul. *Roman Art.* Los Angeles, CA, 2010.

Zimmermann 1977a
Zimmermann, Konrad. "Die Dresdner Antiken und Winckelmann," in *Die Dresdner Antiken und Winckelmann*, Berlin 1977, 45–71.

Zimmermann 1977b
Zimmermann, Konrad. "Vorgeschichte und Anfänge der Dresdner Skulpturensammlung," in *Die Dresdner Antiken und Winckelmann*, Berlin 1977, 9–32

Authors

Björn Christian Ewald is a classical archaeologist and an associate professor of ancient art at the University of Toronto. After studies in classical archaeology, ancient history, and philosophy in Göttingen, Florence, and Munich, he received his master's degree in 1993, and in 1996 completed his PhD on the iconography of Roman sarcophagi at the Ludwig-Maximilians-University, Munich. He received a travel fellowship from the Deutsches Archäologisches Institut from 1997–98 and was a research fellow at the Deutsches Archäologisches Institut in Rome and the Center for Advanced Study in the Visual Arts at the National Gallery of Art in Washington, DC. From 2001–2006 he was an assistant professor of classics and art history at Yale University. He has published widely on ancient art and culture, especially funerary art and myth in art, including *Mit Mythen leben. Die Bilderwelt der römischen Sarkophage* (with Paul Zanker, 2004, English translation: *Living with Myths*, 2012) and *The Emperor and Rome: Space, Representation, and Ritual* (coedited with Carlos F. Noreña, 2010). A most recent publication is "Attic Sarcophagi: Myth Selection and the Heroising Tradition," in *Wandering Myths: Transcultural Uses of Myth in the Ancient World,* eds. Lucy Audley-Miller and Beate Dignas (2018).

Kordelia Knoll, a classical archaeologist, has been working at the sculpture collection of the Staatliche Kunstsammlungen Dresden since 1980, first as a research fellow and later as a senior curator. She studied classics, ancient archaeology, art history, and German at the Friedrich-Schiller-Universität in Jena. She completed her PhD, entitled "Die Geschichte der Dresdener Antiken- und Abgußsammlung von 1785 bis 1915 und ihre Erweiterung zur Skulpturensammlung unter Georg Treu" (The History of the Dresden Antique and Cast Collection from 1785 to 1915 and Its Expansion to a Sculpture Collection under Georg Treu), at the Technische Universität in Dresden in 1993. Her research interests include the history of the Dresden sculpture collection, ancient small-scale antiquaries, and sculpture and their reception. Exhibitions curated for the Staatliche Kunstsammlungen Dresden include *Das Albertinum vor 100 Jahren. Die Skulpturensammlung Georg Treus* (1994); *Verwandelte Götter* with Stephan F. Schröder in Madrid (2008) and Dresden (2009); *Dionysos. Rausch und Ekstase* with Michael Philipp in Hamburg (2013) and Dresden (2014); and *Von Schönheit und Größe. Römische Porträts und ihre barocke Aneignung* with Saskia Wetzig in Dresden (2016). Along with Christiane Vorster, she coedits the catalogs of the collections of ancient sculpture at the Staatliche Kunstsammlungen Dresden.

Saskia Wetzig is a classical archaeologist. She has worked at the sculpture collection of the Staatliche Kunstsammlungen Dresden since 2006. She studied classical archaeology, art history, and ancient history at the Universität Leipzig; her master's thesis was titled "Der Musenzyklus aus dem Odeion der Villa Hadriana" (The Cycle of the Muses from the Odeon at Hadrian's Villa). She has contributed to catalogs of the collection of ancient sculpture at the Staatliche Kunstsammlungen Dresden and cocurated exhibitions, most recently *Von Schönheit und Größe. Römische Porträts und ihre barocke Aneignung* (2016) with Kordelia Knoll. A recent focus of her curatorial work has been the reorganization of the collection of antiquities.

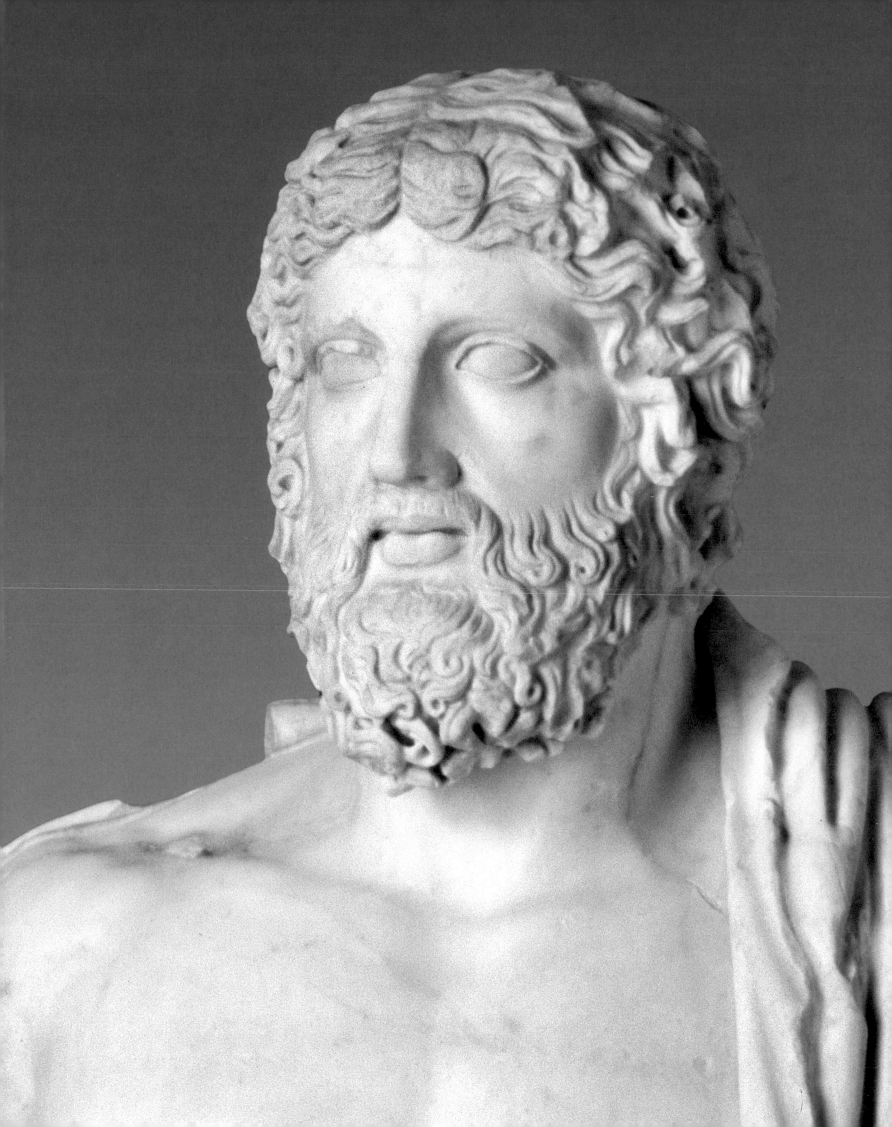

Colophon

This catalog is published in conjunction
with the exhibition

Olympian Gods:
From the Dresden Sculpture Collection
Museum Barberini, Potsdam
November 17, 2018 to February 17, 2019

Barberini Studies 2
Editors:
Stephan Koja, Michael Philipp and
Ortrud Westheider

Exhibition:
Kordelia Knoll and Saskia Wetzig
with Michael Philipp

Catalog Editor: Michael Philipp

Picture Editor: Valerija Kuzema

Museum Barberini, Potsdam

Director: Ortrud Westheider
Director of Finance and
Administration: Claudia Thurow
Chief Curator: Michael Philipp
Curators: Valerie Hortolani, Daniel Zamani
Research Associates: Linda Hacka,
Valerija Kuzema, Julia Nagel
Registrar: Anne Barz
Public Relations: Achim Klapp
IT/Security Coordinator: Remigius Plath
Associate to the Director: Theresa Krämer
Public Relations Assistant: Marte Kräher
Educational Service Coordinators:
Dorothee Entrup, Andrea Schmidt
Event Managers: Julia Teller,
Ines Wenzel-Hirschfeld
Guest Managers: Jutta Bockhacker,
Frauke Herlyn, Laura Widder
Administrative Manager: Yvonne Benesch
Office Manager: Julia Georgi
Chief Engineer: Carsten Loeper
Engineers: Frank Altmann,
Dennis Kokert

In collaboration with:
Conservation:
Felicitas Klein, Berlin
Friederike Beseler, Berlin
Exhibition Design:
Gunther Maria Kolck, Hamburg
BrücknerAping, Büro für Gestaltung, Bremen
Museum Shop:
Museum Barberini. Der Shop, Jörg Klambt
Barberini Digital Guide:
MicroMovie, Potsdam

Catalog

Cover:
Detail of *Statue of Aphrodite*, cat. 8

© 2018. Museum Barberini gGmbH, Potsdam,
authors, and Prestel Verlag, Munich · London ·
New York, a member of Verlagsgruppe
Random House GmbH
Neumarkter Straße 28
81673 Munich

Editorial Direction, Prestel: Markus Eisen
Graphic Design and Typesetting:
BrücknerAping, Büro für Gestaltung, Bremen
Copyediting: Sylee Gore, Only Today, Berlin
Translations from the German: Martina Dervis,
Margaret Hiley
Production Management: Cilly Klotz
Separations: Reproline Genceller, Munich
Printing and Binding: Longo SPA I AG, Bolzano
Typeface: Neue Haas Grotesk
Paper: 150 g/m² Garda Matt Ultra

Verlagsgruppe Random House FSC® N001967

Printed in Italy

With respect to links in the book, Verlags-
gruppe Random House expressly notes that
no illegal content was discernible on the
linked sites at the time the links were created.
The publisher has no influence at all over the
current and future design, content or authorship
of the linked sites. For this reason the Verlags-
gruppe Random House expressly disassoci-
ates itself from all content on linked sites that
has been altered since the link was created
and assumes no liability for such content.

Library of Congress Control Number:
2018961295

A CIP catalog record for this book is available
from the British Library.

ISBN 978-3-7913-5806-2
(German trade edition)
ISBN 978-3-7913-6876-4
(German museum edition)

ISBN 978-3-7913-5828-4
(English trade edition)
ISBN 978-3-7913-6893-1
(English museum edition)

www.prestel.de
www.prestel.com

Image Credits

National Archaeological Museum, Athens
 © Hellenic Ministry of Culture and
 Sports/Archaeological Receipts Fund:
 p. 14 (photo: Giannis Patrikianos)
akg-images, Berlin: De Agostini: p. 15 (photo:
 W. Buss); p. 19 (photo: Andrea Baguzzi)
bpk, Berlin: Scala: pp. 17, 25 (courtesy of
 the Ministero Beni e Att. Culturali)
Bridgeman Images, Berlin: p. 16; Alinari: p. 21
Staatliche Kunstsammlungen Dresden:
 Gemäldegalerie Alte Meister: p. 86 (photo:
 J. Karpinski); Skulpturensammlung: pp. 23,
 31–60, 61 middle left, 62–63, 65–73, 75–77,
 78 right, 79, 83, 85, (photo: H.-P. Klut /
 E. Estel), pp. 64, 74, 80, 82, 84 (photo:
 J. Karpinski), pp. 61 right, 81 (photo: J. Liepe),
 78 left; photo archive: p. 87 (photo: H.
 Krone), p. 88 (photo: K. Klemm)
Ny Carlsberg Glyptotek, Copenhagen: p. 24
 (photo: Ole Haupt)
Björn C. Ewald, Toronto: p. 18
Royal Ontario Museum, Toronto © ROM: p. 9
Artothek, Weilheim: Georg-August-Universität
 Göttingen, Archäologisches Institut: p. 13
 (photo: Stephan Eckardt)
An image was taken from the following
 publication: Agnoli 2002, 271: p. 10

It has not proven possible to locate or contact
copyright holders in all instances. Naturally,
legitimate claims will be satisfied in the
framework of the usual arrangements.